The "Odessey"

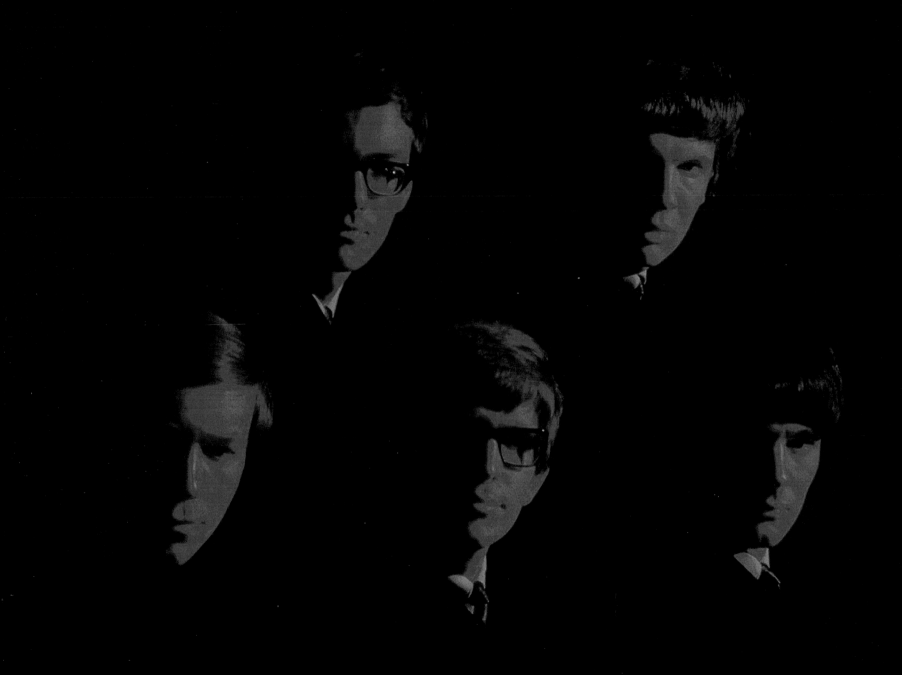

The "Odessey"
The Zombies

IN WORDS AND IMAGES

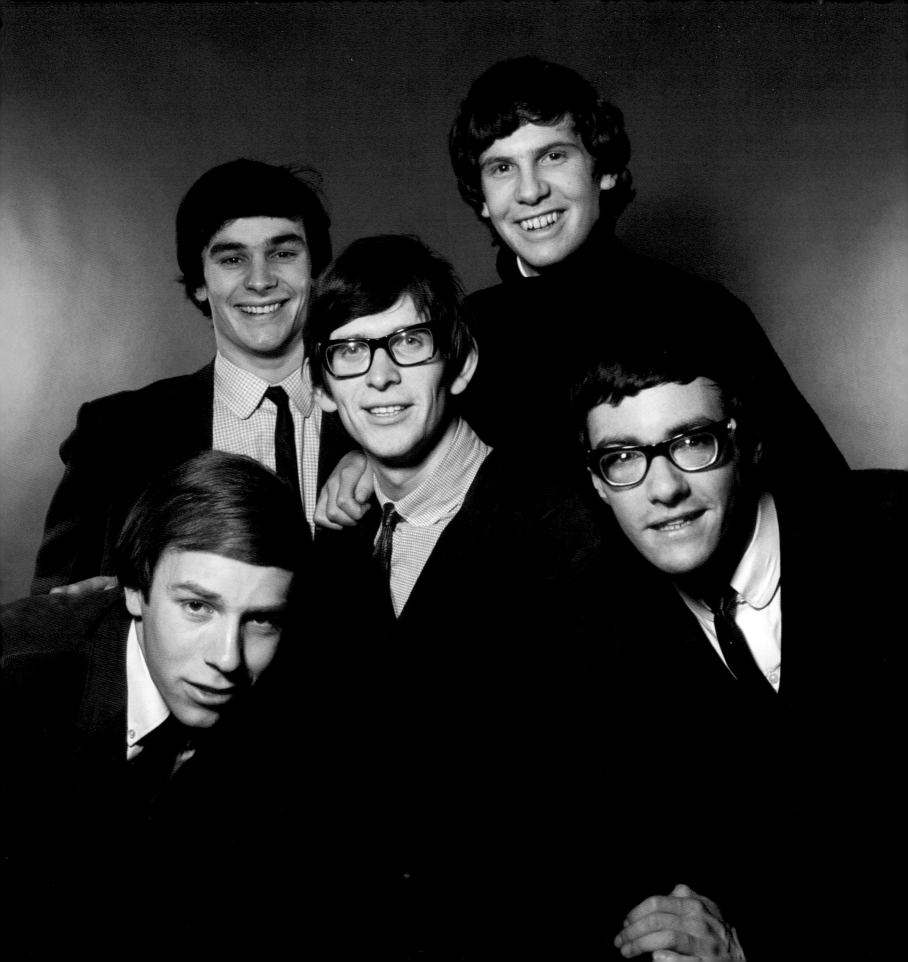

ROD ARGENT
COLIN BLUNSTONE
HUGH GRUNDY
CHRIS WHITE

WITH

SCOTT B. BOMAR
CINDY DA SILVA

FOREWORD BY

TOM PETTY

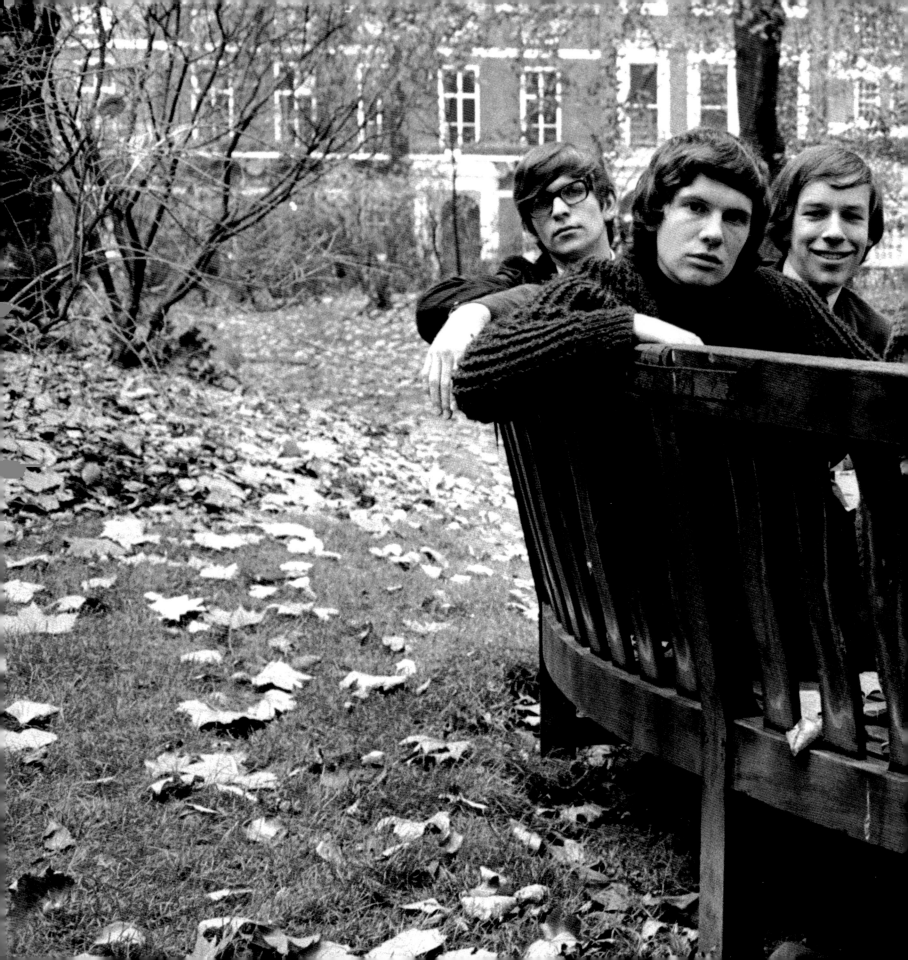

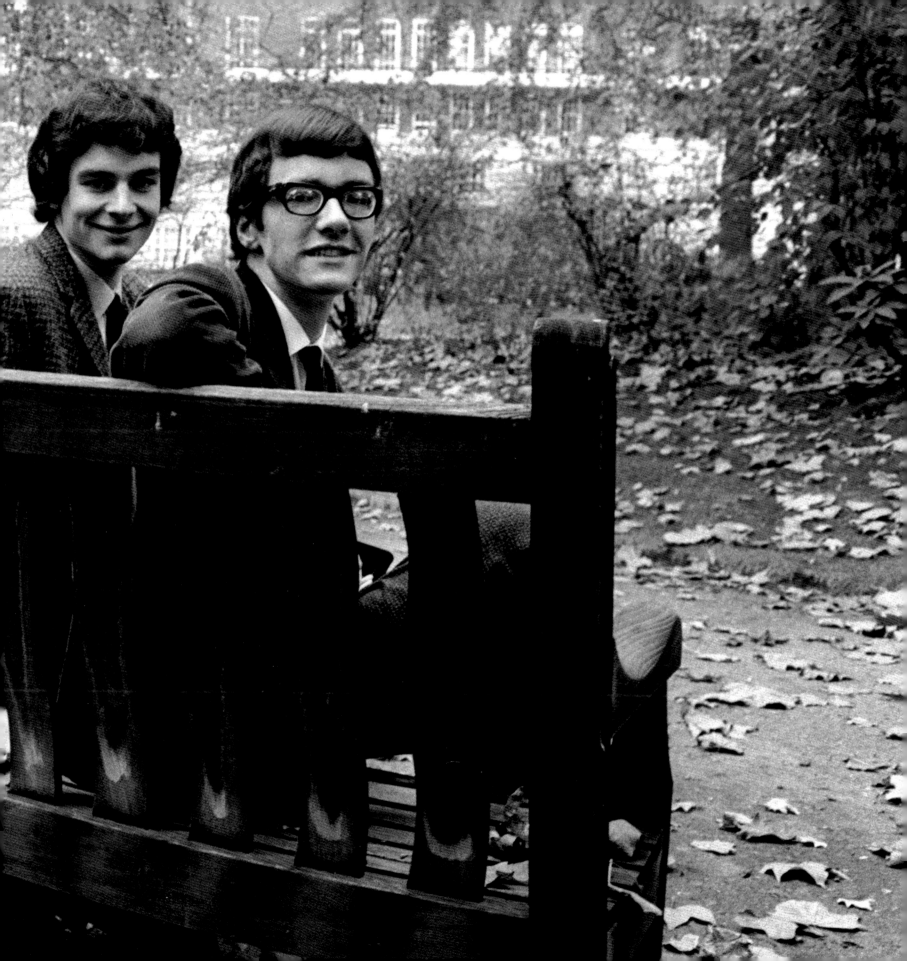

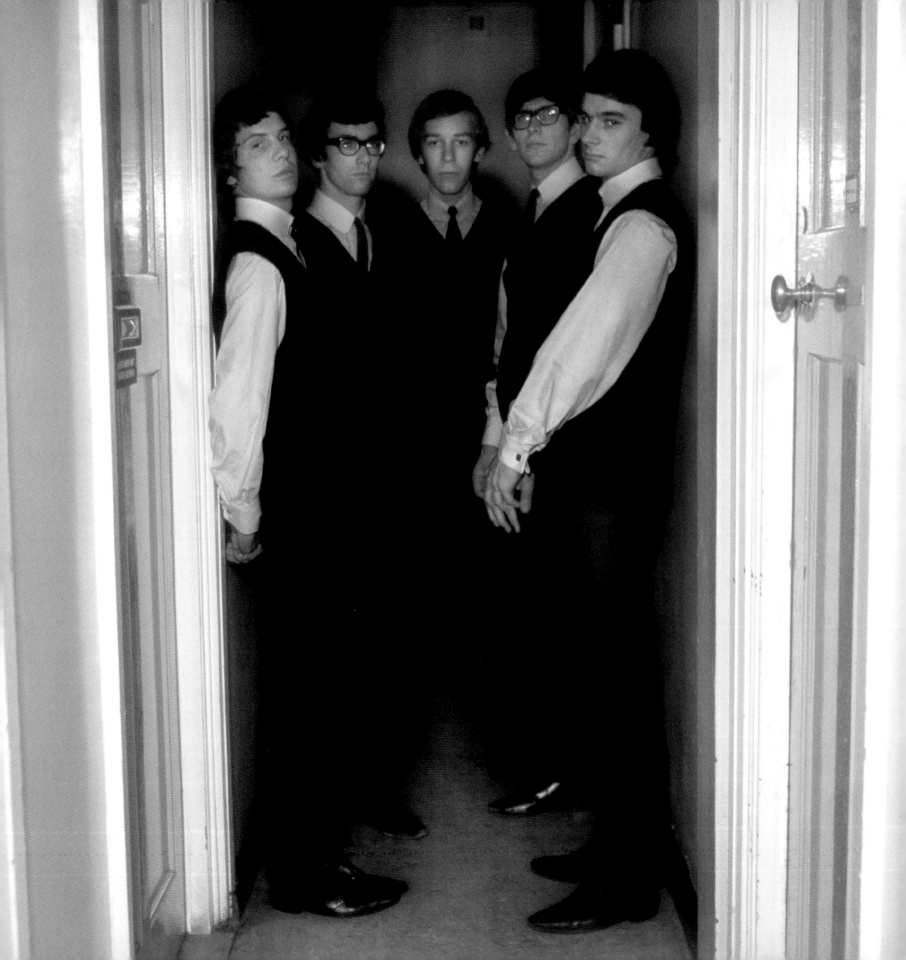

CONTENTS

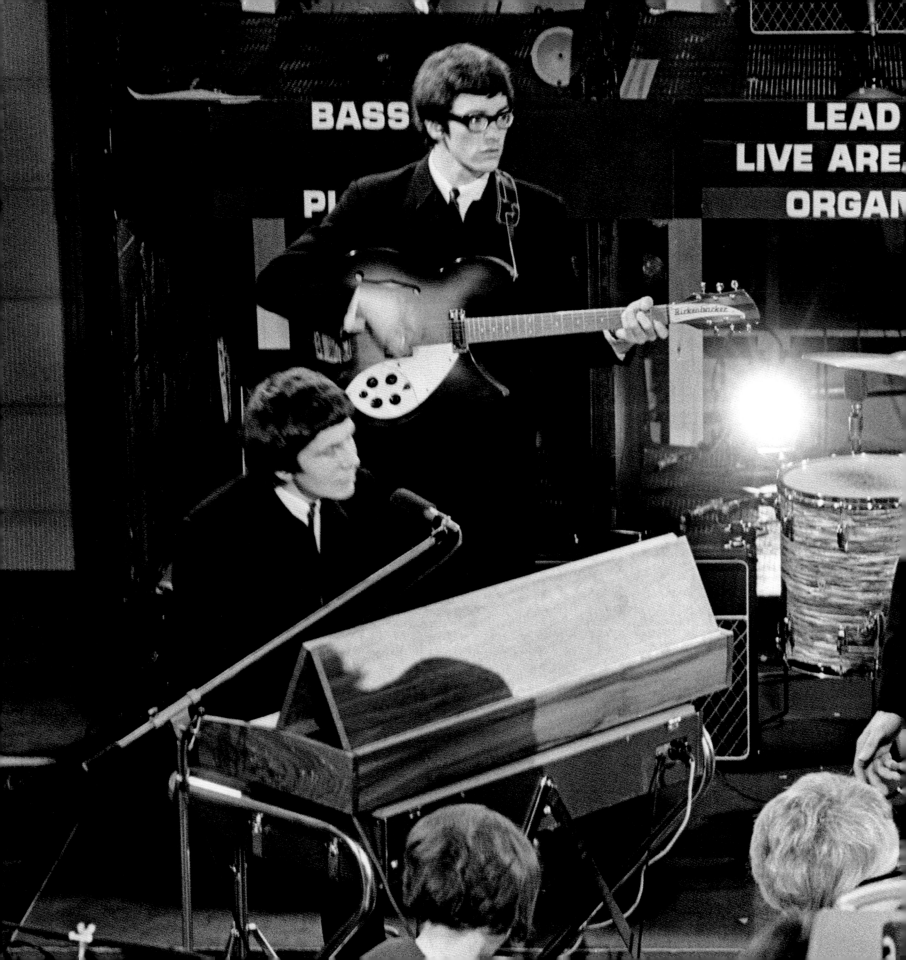

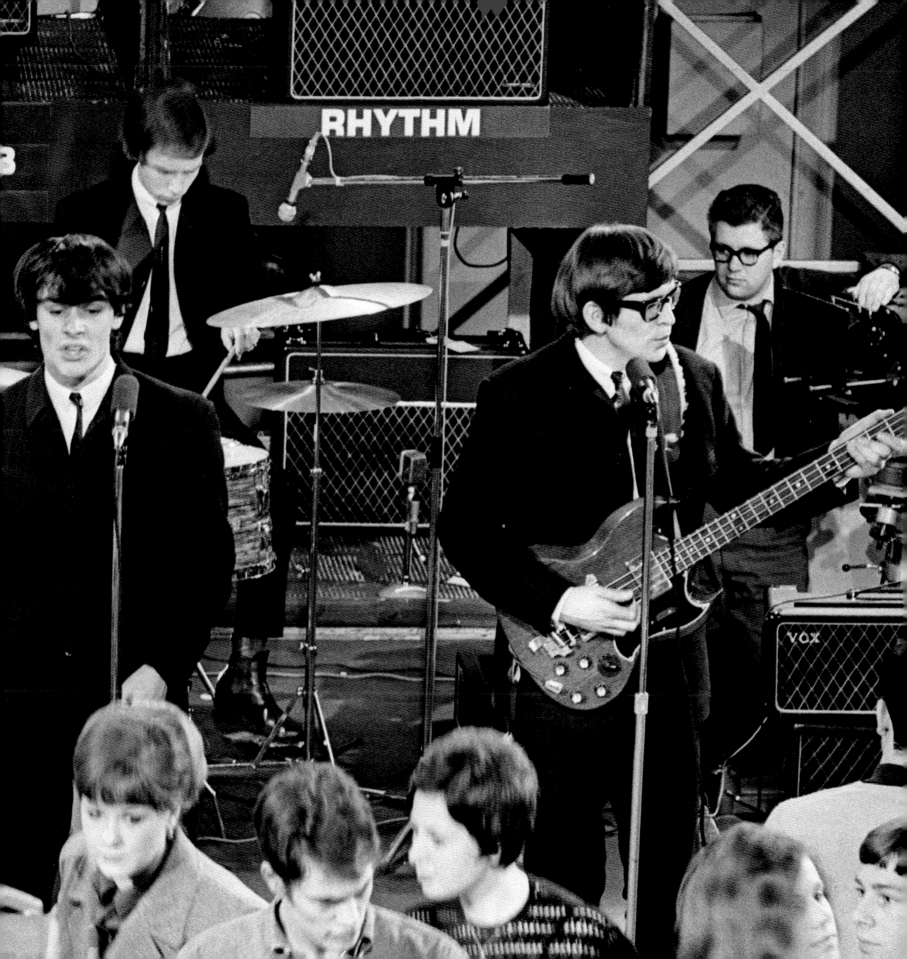

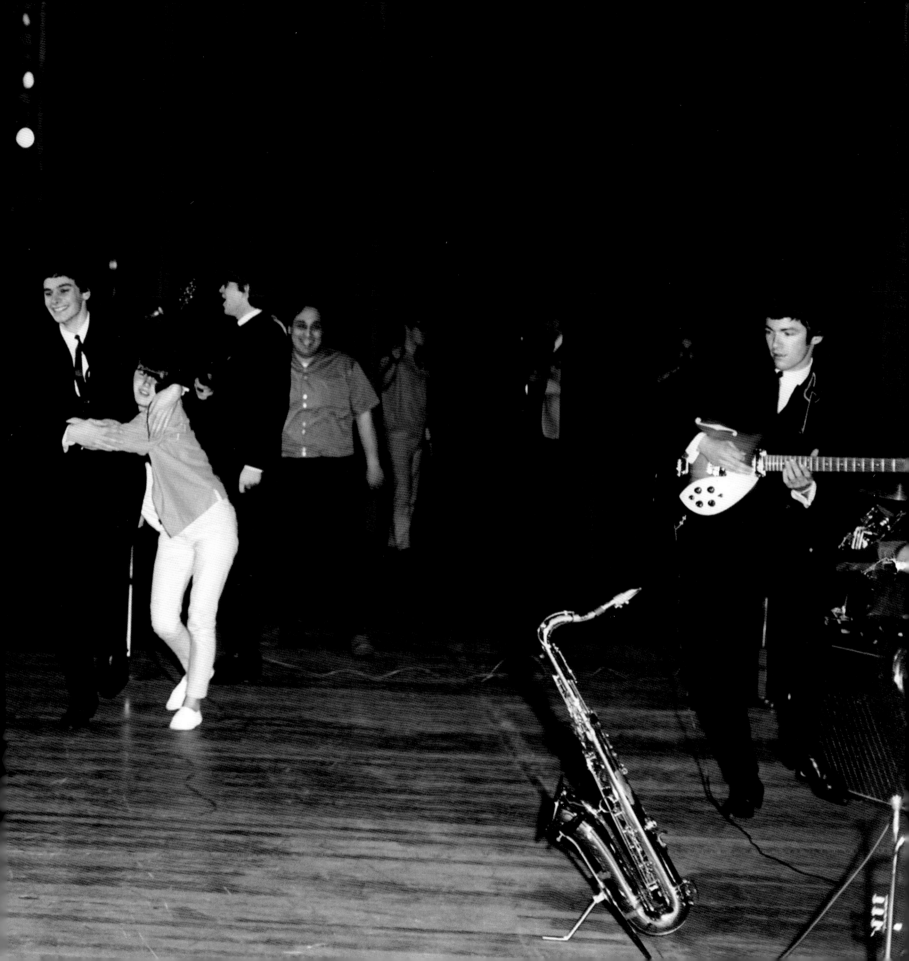

FOREWORD

I remember first hearing "She's Not There" on the radio in my bedroom. It was incredible really. So ethereal. So spooky. This guy was hurt and he wanted to tell me about it. As I wondered who this was, the DJ said it was The Zombies from England. "Of course," I thought. "That is exactly what a zombie rock group would sound like." I should add that the word was far less used in those days, making it even better.

Not long after hearing the record I attended my first rock concert in Jacksonville, Florida. It was 1965, or was it '64? It doesn't matter. The way they did the rock show in that time (I still can't see why it ever changed) was to line up a number of acts who would come on, do their two or three hits, and get off. The more hits you had the longer you played, or something like that. All to be followed by a mammoth superstar to do the last 30 minutes. It was such a religious experience I still remember the running order. It went like this:

The Premiers – of "Farmer John" fame – opened and were the house band.
Del Reeves – a country star who sang his one big hit, looking very confused, and scrammed.
Del Shannon – now we're talking four killer songs, closing with "Runaway."
Lesley Gore – one of the top female singers – did a lot of big radio songs. Handed out sheet music to The Premiers, but I kinda felt they weren't reading it.
The Shangri-Las – without a doubt, the sexiest girl group ever. Boys screamed.
Sam the Sham and the Pharaohs – some bad ass Tex Mex with a turban. Closed with his own "Wooly Bully!"
Intermission
ZOMBIES – from out of the dark that unmistakable voice sang "I'm a road runner honey." Lights up and there they were in their black suits, an honest-to-God British rock and roll band was playin' in Florida! I remember "Summertime" being unbelievably great with a solo on piano that was so musically over the head of the entire show, yet everyone got chills and fever. Five or six songs later they were gone, but as you can see here, unforgettable. They were followed quickly by:
The Searchers – from Liverpool, pro, but a hard spot following The Zombies.
The Beach Boys – the ground shook and you know the rest.

The Zombies, said quite simply and honestly, were an enormous influence on the American musicians of the time. The electric piano and organ had not been manipulated and showcased like that before. The music rocked, but also shimmered with touches of genuine jazz and R&B. Gorgeous two and three part vocal harmonies that rivaled The Beach Boys. Amazing drum and bass arrangements we all stole from. In short, this was so original it hurt.

In '69 they came with their second LP, *Odessey and Oracle*. It was, and is, a masterpiece of the highest order. Think *Pepper*, *Pet Sounds*, etc.

I'm sold.

- Tom Petty

INTRODUCTION

It's 50 years now since we recorded *Odessey and Oracle*, and, unbelievably, interest in the record has never been higher. It feels such a privilege to be part of a band whose music seems able to command a following over several generations, and we wanted to mark our anniversary with something really special to celebrate our relationship with our fans – those special people who have journeyed with us for part or all of the way; who have made it possible for us to both continue to express the joy of performing all our past material, while enthusiastically being able to follow the creative path of new writing and recording. It's something that remains as vital and energizing as ever to us.

So here it is! This book showcases the lyrics of 22 songs that have been an important part of our past and our present, including every track from the *Odessey and Oracle* album. These songs tell the story of The Zombies, as do the pictures, artwork, memories, and testimonials from friends and fans that we've collected here. Think of it as a snapshot of a group that is still experiencing the wonderful journey that music has brought to our lives. We hope you enjoy this eclectic collection of words and images as much as we've enjoyed the opportunity to make music for you for all these years. Here's to many more!

- Rod Argent, The Zombies

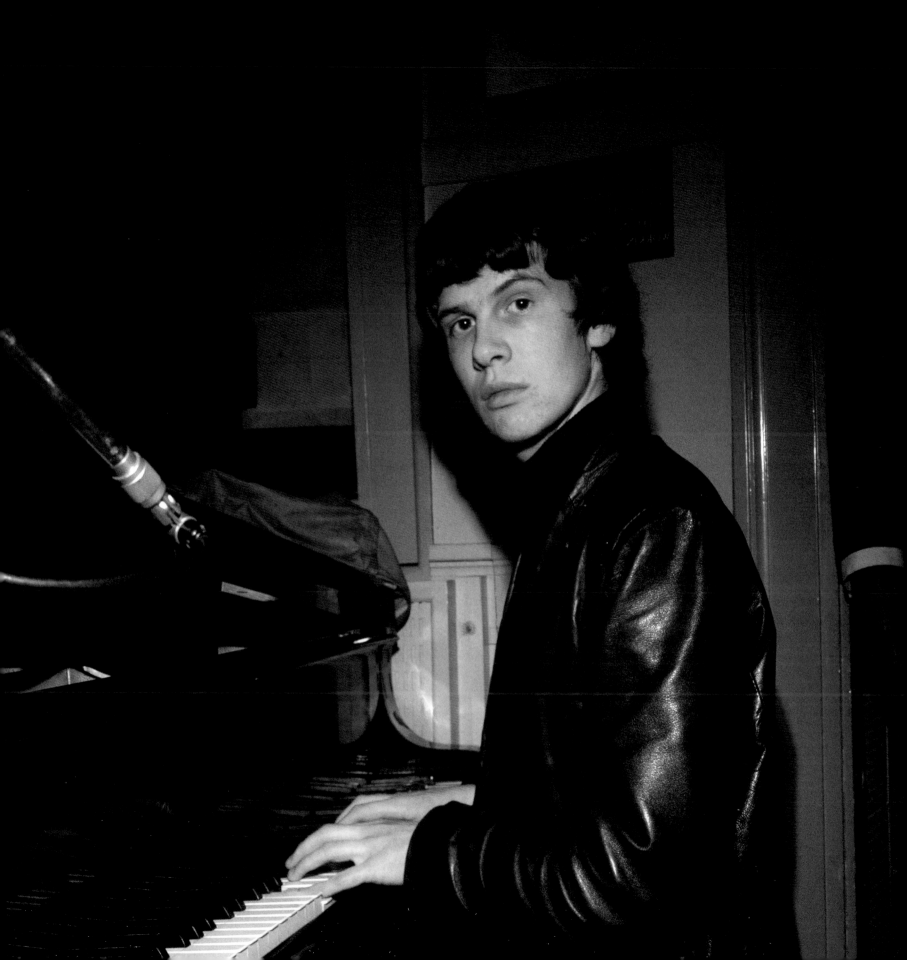

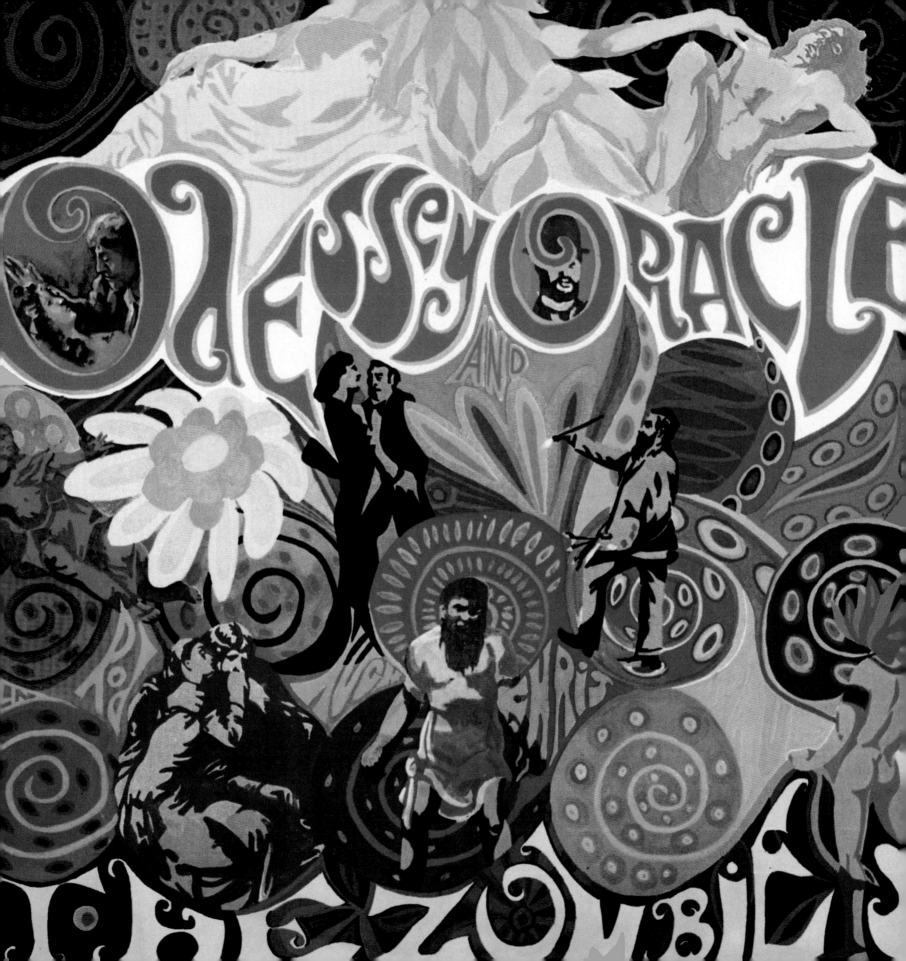

ABOUT THE ARTWORK

The Zombies have always appreciated the marriage of music and powerful imagery, as exemplified by the iconic cover of the *Odessey and Oracle* album. It was designed by Terry Quirk, who attended grammar school with Chris and Colin, went to art school with Chris, and shared a flat in North London with Chris and Rod when the band was recording the LP in 1967. When it came time to come up with a cover for 2015's *Still Got That Hunger* album, Terry was called into service once again. He is a deeply rooted member of The Zombies' family.

Of his iconic 1960s cover, Terry recalls being in the studio with the band when the idea began to take shape. "I can remember sitting on some stairs," he explains, "and it was around half past one in the morning, and they were thinking of titles. I had a pad and a pencil, and they were having a discussion, and out came the word 'odyssey,' and I just wrote it in this floral writing. And then out of it came 'oracle,' and I wrote that down. When the guys came back from a break, I showed it to them and said, 'How about this?' And they said, 'Perfect, absolutely perfect – color it in, put some figures in. You know what the songs are about.' And that was it."

On the final cover, Shakespeare's Romeo and Juliet appear in the "O" of Odessey, while painter and illustrator Toulouse-Lautrec is shown in the Oracle's "O." It was Terry's nod to his deep appreciation of the arts, both written and visual. It's fitting that, for this collection that celebrates The Zombies in both words and images, Terry has designed an entirely new collection of "Os" – one for each of the 22 songs represented. Each was lovingly drawn as a tribute to his longtime friends.

Similarly, Vivienne Boucherat has created 22 original works of art, each of which represents one of the 22 songs included in this volume. Viv, who is married to Chris White, is a visual artist, songwriter, and singer. An accomplished vocalist, she was a member of the London Bulgarian Choir, which was named BBC Radio 3's Choir of the Year – Open Category in 2006. She regularly collaborates musically with Chris, and has sung backing vocals with The Zombies on their "Odessey and Oracle" reunion tours. Viv is not only part of Chris' family but, like Terry, is also an important part of The Zombies' family.

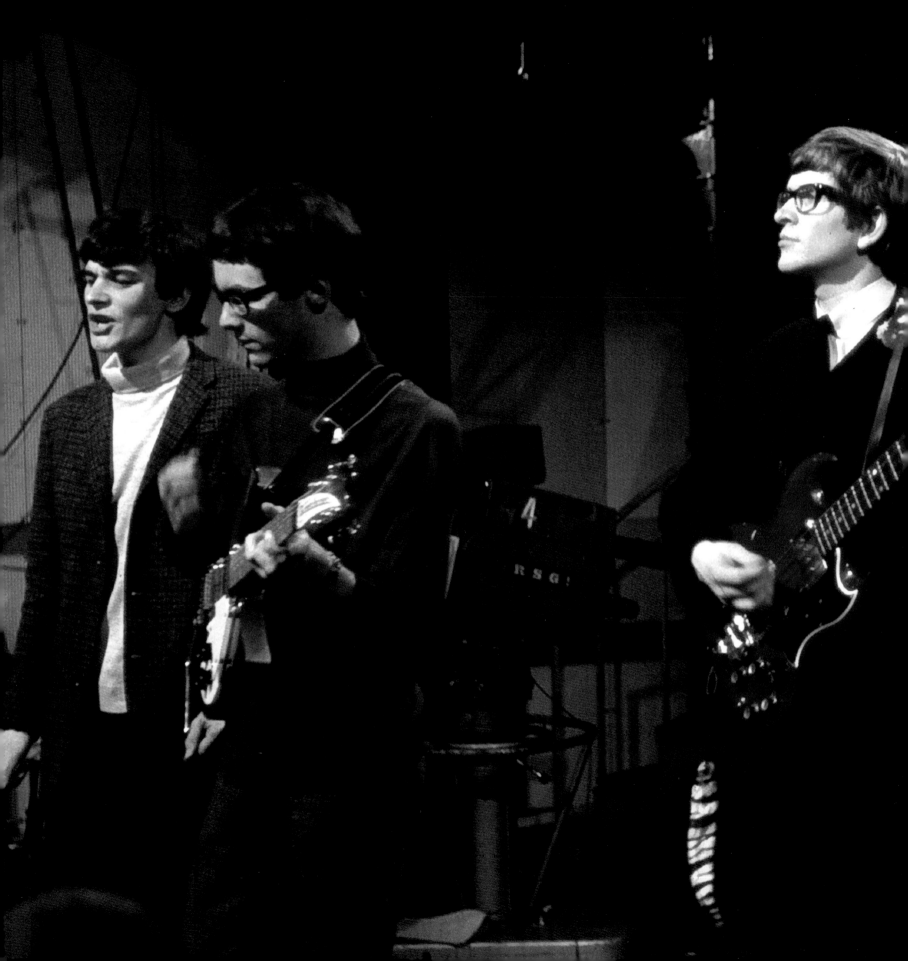

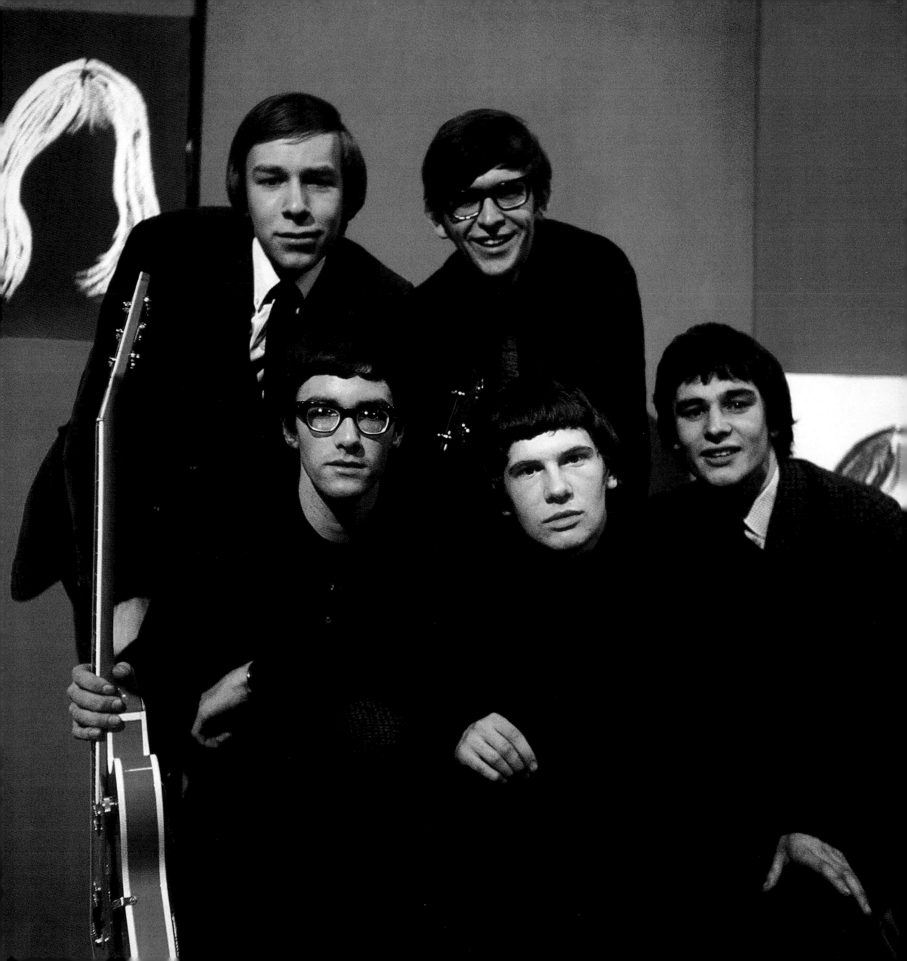

BEGIN HERE:
THE SINGLES YEARS, 1964-1966

"The Zombies – man, they made some great records. I love their harmonies, and songs like 'Time of the Season,' 'Tell Her No,' and 'She's Not There' showed off their immense talent. They really had it goin' on and their music blew my mind." *- Brian Wilson*

The band that would come to be known as The Zombies first formed in 1961 in the city of St. Albans outside London. Keyboardist Rod Argent, guitarist Paul Atkinson, and drummer Hugh Grundy were joined by vocalist Colin Blunstone. They were all teenagers and still in school. The name came from original bassist Paul Arnold, who was soon replaced by Chris White in 1962. Their first single, "She's Not There," fell just shy of the Top 10 in the UK and became the group's only Top 40 hit in their home country.

They were far more successful internationally, particularly in the US, where "She's Not There" reached #1 and sold over a million copies. It was followed soon after by the Top 10 single "Tell Her No." In early 1965, The Zombies toured America, playing for hysterical fans who were swept up in the spirit of the British Invasion. They released one album during this period. The UK version was called *Begin Here*, while the US version, with a slightly different track listing, was simply titled *The Zombies*. Referred to amongst the band members as "the singles era," The Zombies distinguished themselves in this period as a group with a uniquely moody and sophisticated pop style.

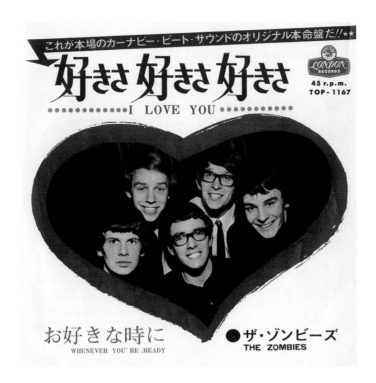

これが本場のカーナビー・ビート・サウンドのオリジナル本命盤だ!!★☆

好きさ 好きさ 好きさ

LONDON RECORDS

45 r.p.m.
TOP-1167

········· I LOVE YOU ·········

お好きな時に
WHENEVER YOU'RE READY

● ザ・ゾンビーズ
THE ZOMBIES

IS THIS THE DREAM □ I WANT YOU BACK AGAIN
I LOVE YOU □□□□ WHENEVER YOU'RE READY

ZOMBIES

457.100 M

DECCA

THIS OLD HEART OF MINE • THE LOOK OF LOVE
JUST A LITTLE BIT • LOVING YOU IS SWEETER THAN EVER

ZOMBIES ON THE BBC

BIG BEAT

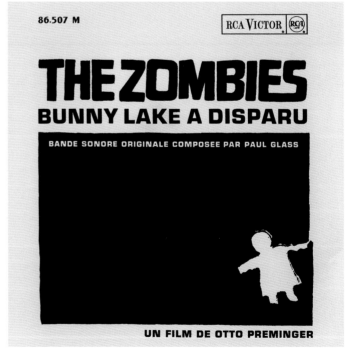

86.507 M

RCA VICTOR RCA

THE ZOMBIES
BUNNY LAKE A DISPARU

BANDE SONORE ORIGINALE COMPOSEE PAR PAUL GLASS

UN FILM DE OTTO PREMINGER

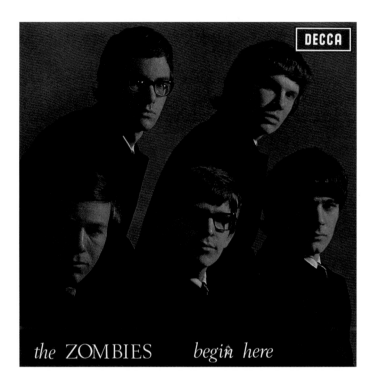

the ZOMBIES *begin here*

DECCA

the zombies

DECCA
LK 4843

THE ZOMBIES
SHE'S COMING HOME

A MARQUIS ENTERPRISE LTD. PRODUCTION
DIRECTED BY KEN JONES

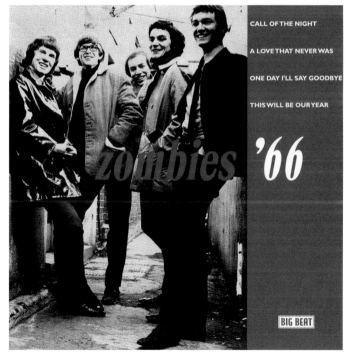

CALL OF THE NIGHT

A LOVE THAT NEVER WAS

ONE DAY I'LL SAY GOODBYE

THIS WILL BE OUR YEAR

zombies '66

BIG BEAT

She's Not There
(Rod Argent)

Single
Released July, 1964 (UK)
Released September, 1964 (US)

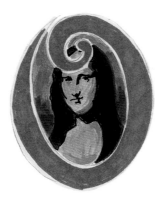

"I heard 'She's Not There' on the radio in the US in the mid '60s and immediately went and bought the single. I got home and sat in my parents' screened-in porch where my 45 player lived. I must have played it 20 times in a row. I had never heard anything quite like it. It was a seminal moment for me. A harmonic awakening. A new sonic landscape. There were inversions I had never heard over such cool innovative rhythmic grooves. And Colin's voice? Forget about it! My voice, while not refined, had a similar range and timbre, so I had found new gurus from across the sea. Fifty years later I would record a cover of the track for a charity album and a concert, featuring The Zombies, to benefit musicians in Austin. I had the thrill of meeting the band, and a mentee's dream had come full circle." - *Christopher Cross*

"I have to thank Mr. Bill Graham for suggesting 'She's Not There,' which appeared on the Santana *Moonflower* album in 1977. Bill believed in this song and knew it would further resonate with people if it was infused with the sound of Santana. I knew the song and loved the melody line, lyrics, and Colin Blunstone's vocals, but it took me some time to hear a Santana arrangement. One day I was driving up Mount Tamalpais and I heard the intro in my mind like Cal Tjader, or the way I hear The Beatles' soundtrack for *Help!* – when they're running towards something and you hear an electric vibe, something mysterious. The track naturally unfolded from there with a marimba vibe, keyboards, and the call and response with percussion section. I am grateful to The Zombies for delivering a great melody and timeless song. It is a song that still touches people's hearts and that I still play in my shows today!" - *Carlos Santana*

She's Not There

Well, no one told me about her
The way she lied
Well, no one told me about her
How many people cried

But it's too late to say you're sorry
How would I know, why should I care?
Please don't bother trying to find her
She's Not There

Well, let me tell you 'bout the way she looked
The way she acted, the colour of her hair
Her voice was soft and cool, her eyes were clear and bright
But she's not there

Well, no one told me about her
What could I do?
Well, no one told me about her
Though they all knew

But it's too late to say you're sorry
How would I know, why should I care?
Please don't bother trying to find her
She's not there

Well, let me tell you 'bout the way she looked
The way she acted, the colour of her hair
Her voice was soft and cool, her eyes were clear and bright
But she's not there

Rod Argent

Rod: I heard Elvis Presley sing "Hound Dog" in 1956 and was completely blown away. From the time I was 11 years old I desperately wanted to be in a band. When I was 15 or 16, I put together a disparate group of people and met Colin Blunstone for the first time at the first rehearsal. We didn't have a lot of knowledge, but we had a lot of enthusiasm and we just kept at it. We built up a really big local following in the first three years and finally entered a contest, called the Herts Beat competition. The prize was the opportunity to record a single for Decca Records, and we won!

Colin: We were introduced to Ken Jones, who was going to produce us for Decca. One day we were having a casual chat with Ken when he mentioned that we could write some original material for our first recording session. It was a passing comment, and we moved on to other topics. To be honest, I didn't give it a second thought.

Chris: Rod and I went away and each wrote something for the band. I wrote "You Make Me Feel Good" and he wrote "She's Not There."

Rod: We had a session in two weeks' time, so I thought, "Where am I going to start?" I put on an old John Lee Hooker album. There was a song on it called "No One Told Me." I quite liked the way that phrase just slipped off the tongue, so I started weaving the story from that line. Even though our song has nothing to do with the John Lee Hooker song, that's where the germ of the lyrical idea came from.

Colin: I was both amazed and thrilled when Rod turned up to rehearsals with "She's Not There" soon afterward. We cut it at our very first recording session, which didn't start off too auspiciously. It quickly became apparent that the recording engineer, who had spent the afternoon at a wedding, was completely and utterly drunk. He was growing more aggressive by the minute and I was quite convinced by his behavior that I would never want to enter a recording studio again! Luckily for us, he eventually passed out cold. We carried him up two flights of stairs and put him in a taxi. I never saw him again. That's when the assistant engineer, Gus Dudgeon, took over. Gus went on to be one of the most successful producers in the world, recording wonderful albums for Elton John, David Bowie, and many others. Not only was "She's Not There" The Zombies' first session, it was Gus Dudgeon's first as well!

Rod: Even though I was in love with Elvis and The Beatles I also discovered Miles Davis and the group he had in the late '50s with John Coltrane, Cannonball Adderley, and Red Garland. I had fallen in love with jazz thanks to Miles and the first real fiery Hammond organ I heard from Jimmy Smith. In an indirect way those influences affected me, which I didn't realize at the time. Those opening chords to "She's Not There" include a little modal phrase that I didn't even know I was doing. The song has a very unusual structure. It starts with a bluesy melodic scale and then it goes into a second section where all the harmonies come in. I wanted a lot of harmony on the record. The third section is where it built to a real climax. I had it in my head to change the meter of the lyric to build up momentum to finish on a major chord before dropping down to the minor chord again for the verse.

Chris: "She's Not There" was such a special song. It was so unusual and was the obvious choice for a first single. It was a toss-up which would be the "A" side. I'm glad to say that "She's Not There" was chosen. And the rest is history!

Hugh: I remember recording "She's Not There" at Decca's West Hampstead studio and thinking it was a very special track. In my young naiveté I just expected it to be a hit. That was the confidence of youth. But I never would have imagined, at the time, the impact it would have on the rest of my life.

Rod: Many years later we found out that Elvis had "She's Not There" on his jukebox. In a period of eight years I heard "Hound Dog" for the first time, had my musical life knocked sideways, and got a #1 record in the United States that ended up on Elvis's jukebox. Unbelievable!

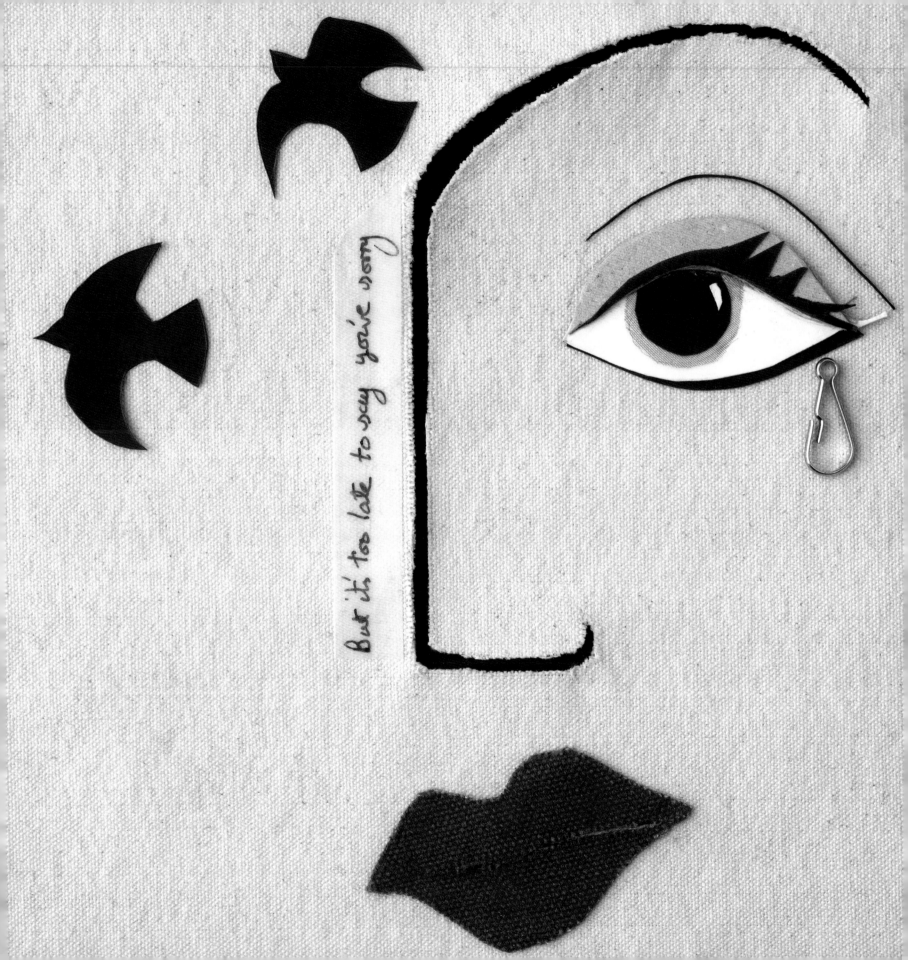

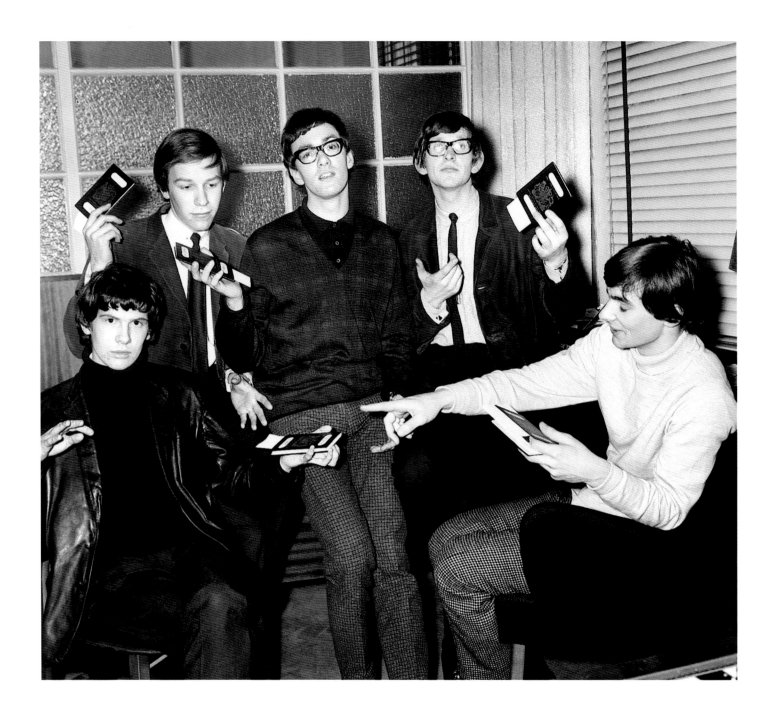

"She's Not There" reaches #1 on the American chart and #4 on the British chart, December 1964.

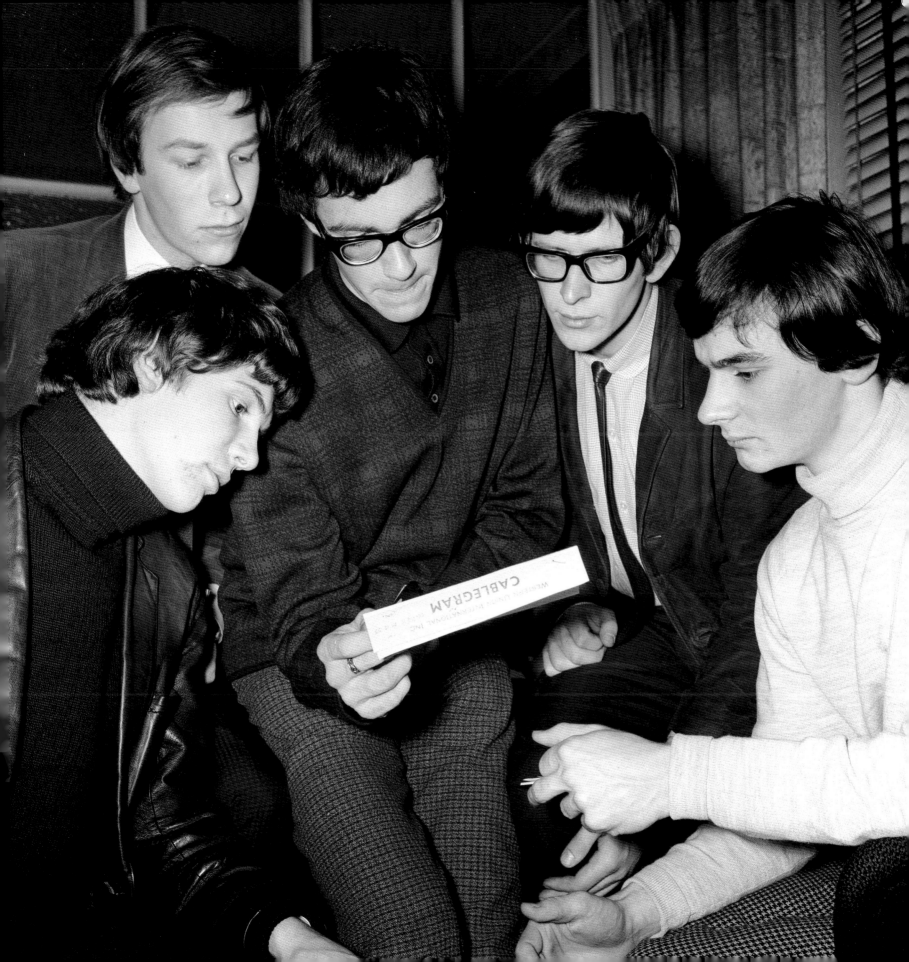

You Make Me Feel Good

You don't need any reason, do you baby
Surely you should know that by now
But if you need a reason
I'll give one to you
You make me feel good
You make me feel good

I don't need any reason when I hold you
I never do ask myself why
But if you need a reason
I'll give one to you
You make me feel good
You make me feel good

So good, so good
don't have to justify
why I feel so good, so good, so good
Never thought could be
So good to me.

Chris White

You Make Me Feel Good
(Chris White)

B-side
Released July, 1964 (UK)
Released September, 1964 (US)

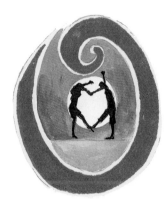

Colin: Chris came up with "You Make Me Feel Good" around the same time Rod came up with "She's Not There." It wound up becoming the B-side of our first single.

Rod: "She's Not There" was the second song I ever wrote and Chris was very new to songwriting at the time as well.

Chris: "You Make Me Feel Good" wasn't the first song I wrote, but it was the first one that we considered good enough to actually record. In terms of songwriting, Buddy Holly was a big influence on a lot of British musicians, as well as Del Shannon. Of course, when The Beatles came along, we thought, "We can do that!" We didn't realize how difficult it was going to be. Rod had written a song that we played onstage when we won the first Beat contest, but we hadn't recorded it.

Rod: We were playing R&B songs and Motown and a lot of American stuff like Chuck Berry and Bo Diddley. And the audiences we were playing for wanted to hear Beatles covers. When we did our first album we couldn't go do a bunch of Beatles songs, so we had to have some originals, even if we included some R&B things, too. That meant that we suddenly needed some songs. The whole first album was recorded in two days. Every piece of an idea that we came up with we recorded. There are very few things I've ever written that we haven't recorded. It wasn't like we had an overabundance of material. Instead, we had to come up with songs to keep moving forward!

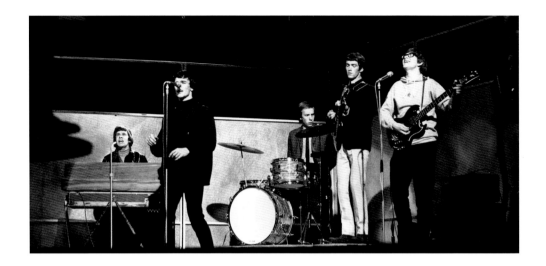

Chris: We'd written songs for ourselves, but we hadn't really considered doing them as a band at the time. People wanted to hear cover songs of what was currently popular, so that was our focus. We thought we could probably write, but it was working together as musicians that really brought the songs to life for us. We worked independently to get the basic songs written, but when we'd rehearse we'd make suggestions to each other. It evolved from there.

Rod: Even before we'd heard The Beatles we were singing three part harmonies, which was unusual in those days. We would always arrange harmonies around the lead vocal. Both "She's Not There" and "You Make Me Feel Good" have the harmonies and, when we started out, we were the only group I'd heard of that was doing that kind of thing.

Chris: There was some Beatles influence in "You Make Me Feel Good," but it was really more about what was in the air at that time. Rod was very good with arranging harmony, thanks to his experience as a chorister, and it worked nicely on the record.

Rod: We recorded both "You Make Me Feel Good" and "She's Not There" at the first session, and it wasn't clear, at first, which would be the A-side of the first single. Different people had different opinions, but Ken Jones, our producer, came down on the side of "She's Not There." Honestly, "You Make Me Feel Good" could easily have been the first single. In my opinion, it definitely should have been the second. The actual second single was a song that none of us were happy with at the time. We didn't want it to come out and, in fact, it didn't come out in the States. "You Make Me Feel Good" is a very good record and if it had been the follow-up to the first single I think it could have changed things for us in the UK.

Hugh: "You Make Me Feel Good" is a song I've always wished we could re-record. It's a great song, and I think it could be a hit.

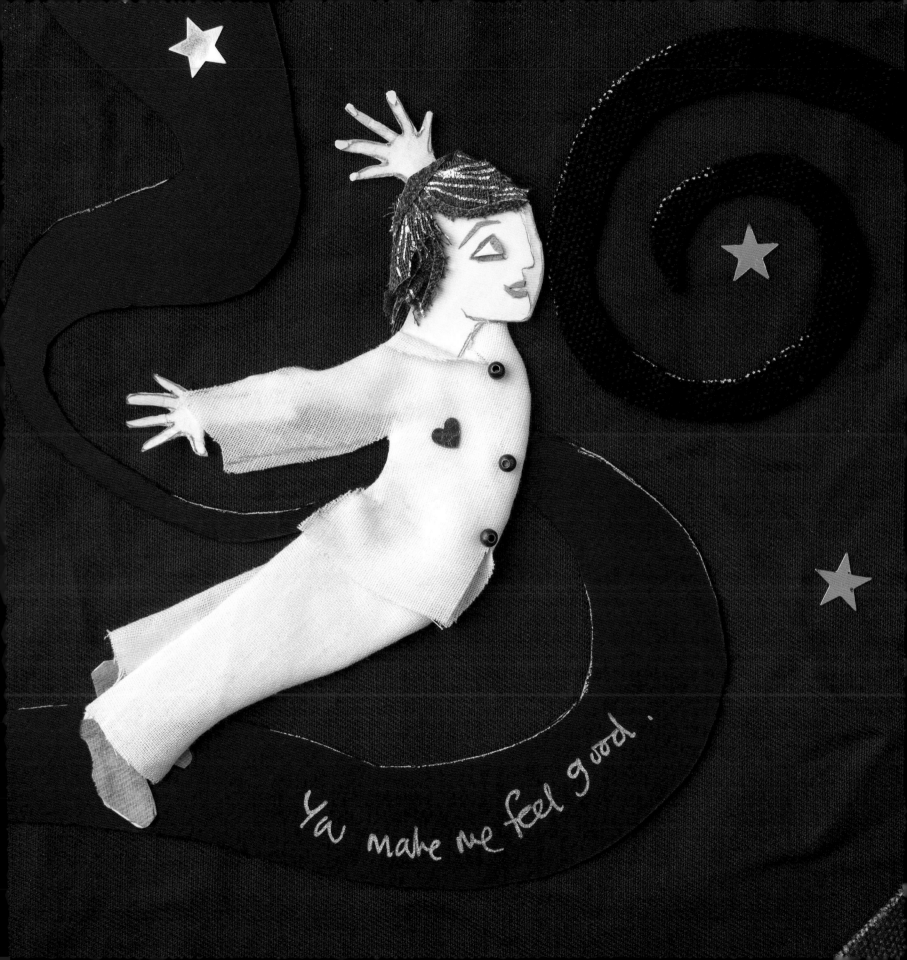

ya make me feel good.

Tell Her No
(Rod Argent)

Single
Released December, 1964 (US)
Released January, 1965 (UK)

"My high school band, Fushia, covered both 'She's Not There' and 'Tell Her No,' and I tried my best to even come close to Colin Blunstone's vocal beauty. He is one of the most distinctively pure voices ever in rock music. Even calling The Zombies' music 'rock' doesn't really do it justice. The Zombies are part rock, part jazz, part pop, part folk, and all cool. Our whole band stood side stage and watched their entire show when we played a festival together in Michigan a few years ago. Blunstone's voice was perfect as always. Only problem was we were late going on because I stayed and listened to their entire set." - *Kevin Cronin, REO Speedwagon*

"The Zombies only made an intermittent impression on the pop charts in their early career. That in itself didn't offer a lot of promise for the potential influence and impact of a band that found itself on the front lines of the British Invasion. Nevertheless, 'Tell Her No,' the band's second single to scale the charts in the US (it climbed into the Top 10 although it was sadly only a minor hit for them at home), made an indelible imprint on their trajectory, a timeless touchstone that serves them well even today. It's no wonder really – Colin's staggered vocals, Rod's bluesy piano licks and the rest of the band's effectiveness in creating a strut and swagger allowed the song to quickly imbue itself into America's collective consciousness while elevating the band to the stature it deserved. Besides, what other song fashions a hook around the repetition of the word 'no' some 63 times? Then again, who's counting? Suffice it to say, 'Tell Her No' remains a classic song of monumental proportions. What's more affirmative than that?" - *Lee Zimmerman, music journalist*

Tell Her No

And if she should tell you, "Come closer",
And if she tempts you with her charms
(chorus) (Tell her no, no, no, no, no-no-no-no
BVs
 No, no, no, no, no-no-no-no
 No, no, no, no, no)
 Don't hurt me now, for her love belongs to me

And if she should tell you, "I love you", (whoa-whoa)
And if she tempts you with her charms
(BVs - Tell her no, etc...)

 Oh, - don't take this love from my arms
 Oh, don't hurt me now, for her love belongs to me
I know she's the kind of girl to throw my love away
But I still love her so - don't hurt me now,
 Don't hurt me now..

 If she tells you, "I love you"
Just remember, she said that to me
(B.V. chorus - Tell her no, etc)
 Oh, don't take her love from my arms
 Oh, oh, don't leave me now, for her love belongs to me

Rod Argent

Colin: We had toured with the amazing Dionne Warwick, who sang so many wonderful Burt Bacharach and Hal David compositions. Bacharach's style was what inspired Rod to come up with the chord structure for "Tell Her No."

Rod: As a songwriter, I wanted to find interesting chord sequences that teased the ear right from the blueprint of the song. Burt Bacharach was using marvelous chords colored by wonderful harmonics. It was very unusual for pop music at that time and I thought, "I've got to write something using those kinds of chord voicings." We were knocked out with everything that was coming from America then, particularly some of the great soul and Motown music that was both soulful and harmonically literate.

Chris: Rod was also inspired by the rhythms of Bacharach's songs. He played "Tell Her No" for us and we learned that infectious pattern.

Hugh: The rhythm on "Tell Her No" was a real challenge for me. I hadn't been playing drums very long, and the feel of the chorus was something that didn't come naturally at all. I had to think about that song a lot, but I think I recorded it OK.

Colin: I have to admit I fell asleep while the rest of the band was recording the basic tracks for "Tell Her No." I was oh-so-rudely awoken to go sing the lead vocal and, being half asleep, I mumbled the lyric in the second chorus. I thought we'd go back and correct it, but our producer, Ken Jones, said, "Don't worry about it." To my extreme embarrassment, it was released with that sleepy mumble in the middle of it. Then again, the single hit the Top 5 in the US and sold over a half million copies. Maybe I should have started mumbling a bit more often when recording!

Chris: "Tell Her No" is a great song. At one point it was in the *Guinness Book of World Records* as the song with the most repetitions of a single word. That word, of course, was "no."

Colin: It was while doing the all night recording session for "Tell Her No" at Decca's West Hampstead Studios in London that we received a phone call from our American publisher telling us that "She's Not There" had reached the #1 position on the *Cashbox* charts in the US. We were absolutely delighted.

And if she should tell you "come closer"

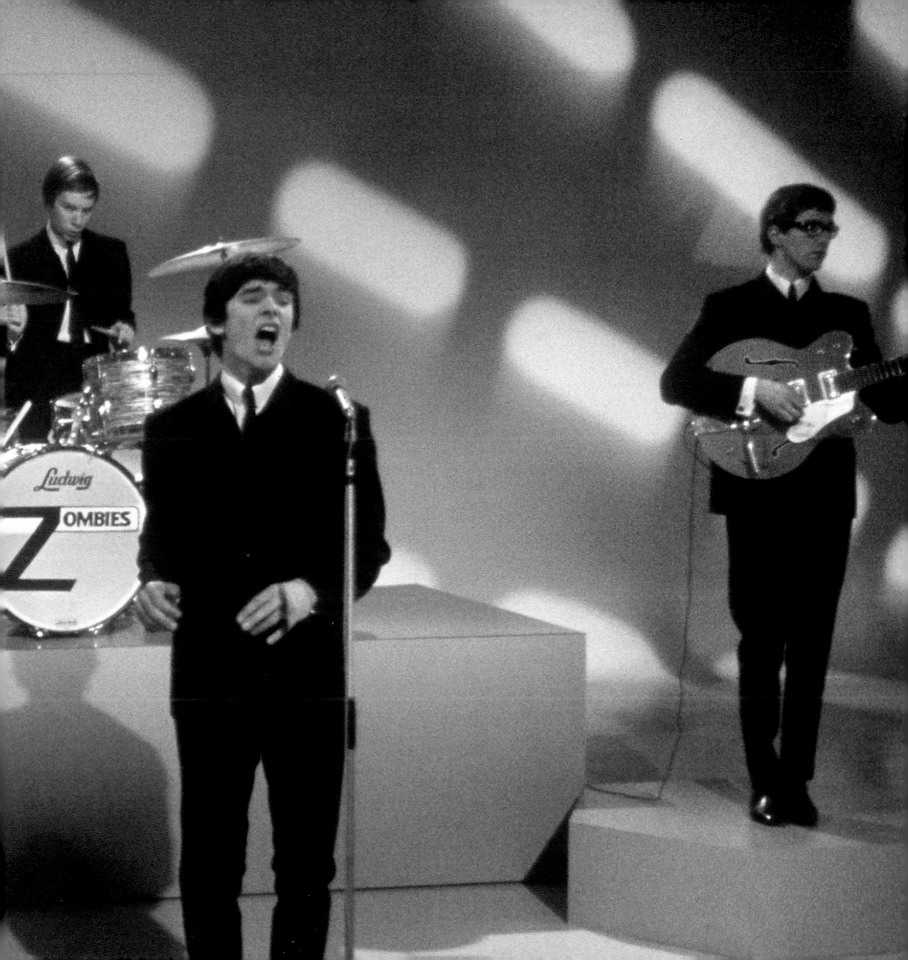

Just Out Of Reach
(Colin Blunstone)

Bunny Lake is Missing (Original Soundtrack LP); Single
Released October, 1965 (US)
Released January, 1966 (UK)

Rod: We met Otto Preminger, who was directing a film called *Bunny Lake is Missing* with Laurence Olivier. He was auditioning different groups to choose one to appear in the film. At our audition we played "Summertime." Otto loved that because he knew George Gershwin in the early days. He wanted us to do the film, but he needed three or four songs very quickly.

Colin: Otto asked us to write and record three songs in about ten days for *Bunny Lake*. Chris had a couple of ideas, but Rod didn't have any songs, so I thought I'd have a go at it. I came up with this bit of '60s fun!

Rod: Chris wrote a couple of songs and Colin wrote one. That might have been the first song Colin ever wrote. I still have an affection for it to this day. It's very 1960s, and I like it because of that. It has a great feel for the period. Colin tells the story that he thought songwriting wasn't for people in the group. He couldn't believe it when Chris and I started making up songs of our own. During the period when we had quite a few hit records, we ended up with almost nothing from our touring. We were very lucky to have honest publishers, so we got royalties from the records and from the publishing. From the touring side, however, we were somewhat ripped off, to put it bluntly. Colin saw Chris and me, as the writers, getting a great income because we were actually being paid the publishing and songwriting royalties that we should have been.

Just Out Of Reach.

Time has changed you I can see
Try to remember how we used to be
Come on back to me
Just out of reach.

Don't stand back and you will see
Just how easy it can be
But you stand contentedly
Just out of reach.

Time will show I mean what I say
You'll see, you'll see
You'll wonder why you doubted
 my word
When our love was meant to be

Come on home you'll be glad
Back here I won't be mad
Funny you should be the one to make
 me feel sad
Just out of reach!

 Colin Blunstone.

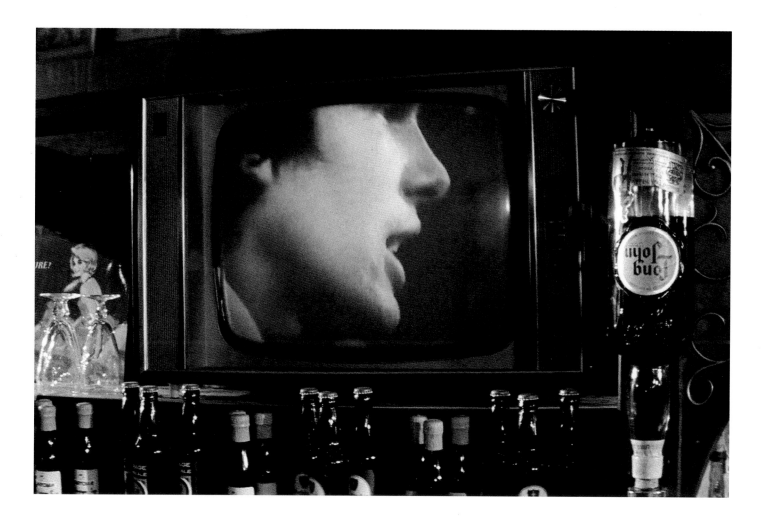

Chris: Colin likes to say he turned up at rehearsal once on his bicycle while Rod was in a Rolls Royce. He said, "There must be something to this songwriting!"

Rod: Colin was very happy to get into the game and try his hand at writing. He thought it would be a more successful way to go. In a sense it was commercially driven, but he was excited to take on the challenge at the same time.

Hugh: When it came time to shoot our scenes, the great Otto Preminger had us there all day at the old *Ready Steady Go!* studio taking loads and loads of film. At the end of the day we were all getting tired and he had the audience rush the stage. It was frightening, actually. There were instruments everywhere and drums being knocked over. It was a bit shocking, I must say! In the final edit it turned out we were just in the background on a television screen in a pub.

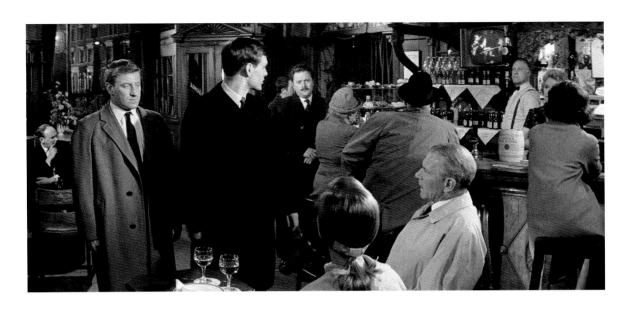

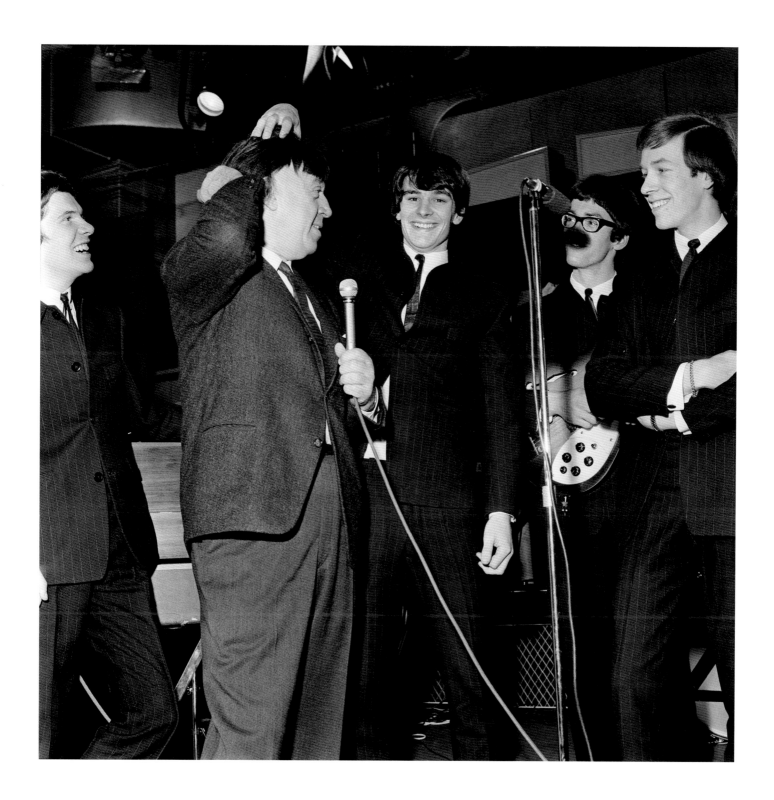

The Way I Feel Inside

Should I try to hide
The way I feel inside
My heart for you?

Would you say that you
Would try to love me too?

In your mind

Could you ever be
Really close to me?

I can tell the way you smile

If I feel that I
Could be certain, then
I would say the things
I want to say tonight

But 'til I can see
That you really care for me

I will dream
That someday you'll be
Really close to me

I can tell the way you smile

If I feel that I
Could be certain, then
I would say the things
I want to say tonight

But 'til I can see
That you really care for me
I'll keep trying to hide
The way I feel inside

Rod Argent

The Way I Feel Inside
(Rod Argent)

Album track (UK), B-Side (US)
Released April, 1965 (UK)
Released September, 1966 (US)

"When 'The Way I Feel Inside' begins to play, I'm suddenly in the same room as Colin Blunstone in 1964 as he crosses the hardwood floor of the studio and approaches a microphone. Without any musical accompaniment he sings with a hushed croon questioning the possibilities of love. It's always the ultimate test of a melody if it can live solely on its own, and the melancholy counterpoint of his carefully and softly chosen notes makes me believe exactly what the title states. This continues to be one of my all-time favorite songs." *- BORNS*

Rod: We were on tour with The Isley Brothers and Dionne Warwick in the UK.

Chris: It was one of those round Britain coach tours with several other acts, traveling with all the artists on a large bus.

Rod: We stopped for a coffee break when I went into the bathroom and suddenly had an idea for this song.

Chris: Rod was late getting back to the bus.

Rod: I stayed in the bathroom for about 20 minutes and got into real trouble. When I returned everyone said, "Where the hell have you been? You've held the bus up!" Colin said, "What on earth were you doing in there?"

Chris: It turns out that he had been on the toilet composing "The Way I Feel Inside" in his head.

Rod: I'd written the whole tune with most of the lyric ideas on a scrap of paper. I had the whole chord sequence in my head, but when we played it, it sounded really ordinary. It was Ken Jones who suggested that we take the backing instruments out and have Colin sing it by himself until the end. That was his idea, and it worked beautifully.

Colin: It was quite challenging to sing most of the song on my own and stay in perfect tune for the band to join me at the end. Maybe it's because I was so focused on getting it right, but I don't remember having to do many takes before we nailed it. Ken Jones added the coin dropping effect at the beginning of the song. I think perhaps my solo performance reminded him of a street busker waiting for someone to reward his performance with a coin or two!

Hugh: I don't think I was in the studio for the recording of this song. Since it was acoustic, and didn't have drums, I didn't play. But I thought the walk-in and the coin drop effect was inspired. I do remember being there to record the coin drop because we had to do it quite a lot to get the sound right. I thought it was pretty clever to use that on the record.

Chris: I'm glad Rod took so long in the restroom! It's more difficult to write songs when you're touring, but we were spurred on by needing to write. I suppose you have to follow inspiration when it strikes.

Rod: It only struck me later the humor of the title, given the circumstances of the composition!

I Love You
(Chris White)

B-Side
Released August, 1965 (US)
Released September, 1965 (UK)

I Love You

Chorus I love you, I love you, I love you, yes I do
 I love you, I love you, I love you, yes I do
 But the words won't come
 And I don't know what to say

I should tell you, 'I love you, I do'...
My words should explain, but the words won't come
I shouldn't hide my love deep inside
My words should explain, but the words won't come
 I should tell you just how I feel
 And I keep trying
 But something holds me back
 When I try to tell you

 Chorus

If I could find the words in my mind
The words should explain, but the words won't come
If you could see what you mean to me
My words should explain, but the words won't come
 And oh how hard I tried to tell you
 'I love you'
 But something holds me back
 When I try to tell you
 Chorus

 Chris White

Chris: We were in America, on a Dick Clark tour, when I heard someone noodling on a guitar. I really liked the A minor to F major chord pattern that I heard. I developed that into the repetitious "I Love You" refrain. When we recorded it at Decca Studios we originally came straight in with the vocals at the beginning of the song, but Ken Jones suggested putting the instrumental section first. Ken was very good and did a lot for us, but he didn't allow us to be involved in mixing songs and that kind of thing, so we actually recorded it with the vocals first. Then he edited it where the instrumental part came first. We objected to not being at mixes sometimes, because we felt very protective of our songs and wanted to be more involved. In this case, though, we thought his decision was better! He was very good, but we thought we could do it ourselves.

Colin: "I Love You" was originally released as the B-side of "Whenever You're Ready," so it was a bit strange when a band called People covered it and scored a Top 15 hit with it in the US. Of course, that did give more attention to The Zombies' name, but it's only natural to wish that we had made it into a hit ourselves.

Rod: We never played it live in the first incarnation of The Zombies, but in the current incarnation, we listened to People's version again and realized they put a slightly funkier attitude on it with a pumping bass on the chorus. We kept the original harmonies and original structure of the song, but we took on that slightly funkier attitude and we really started to enjoy doing it. We love playing it now!

Hugh: I don't remember much about recording it, but it's such a great pleasure to hear the touring band play "I Love You" now. They play it so well!

Colin: We have incorporated some of the People arrangement in our performance, so you could say we're covering a version of a song that was a cover of our song in the first place!

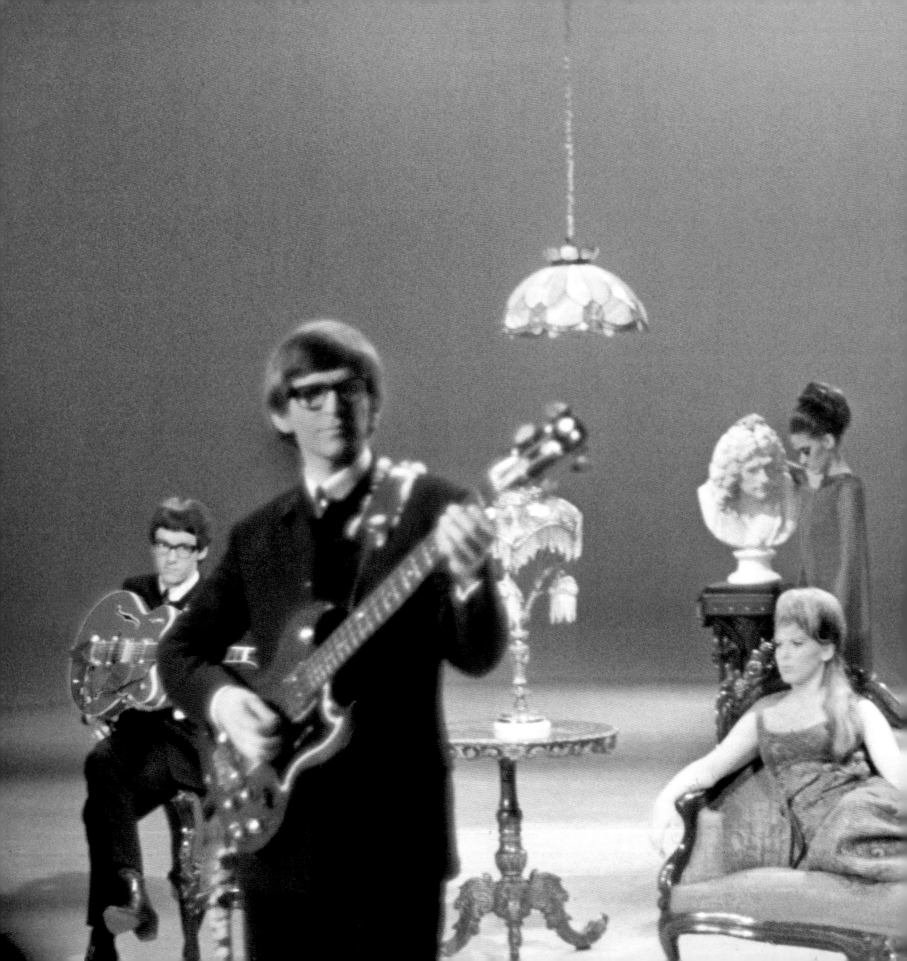

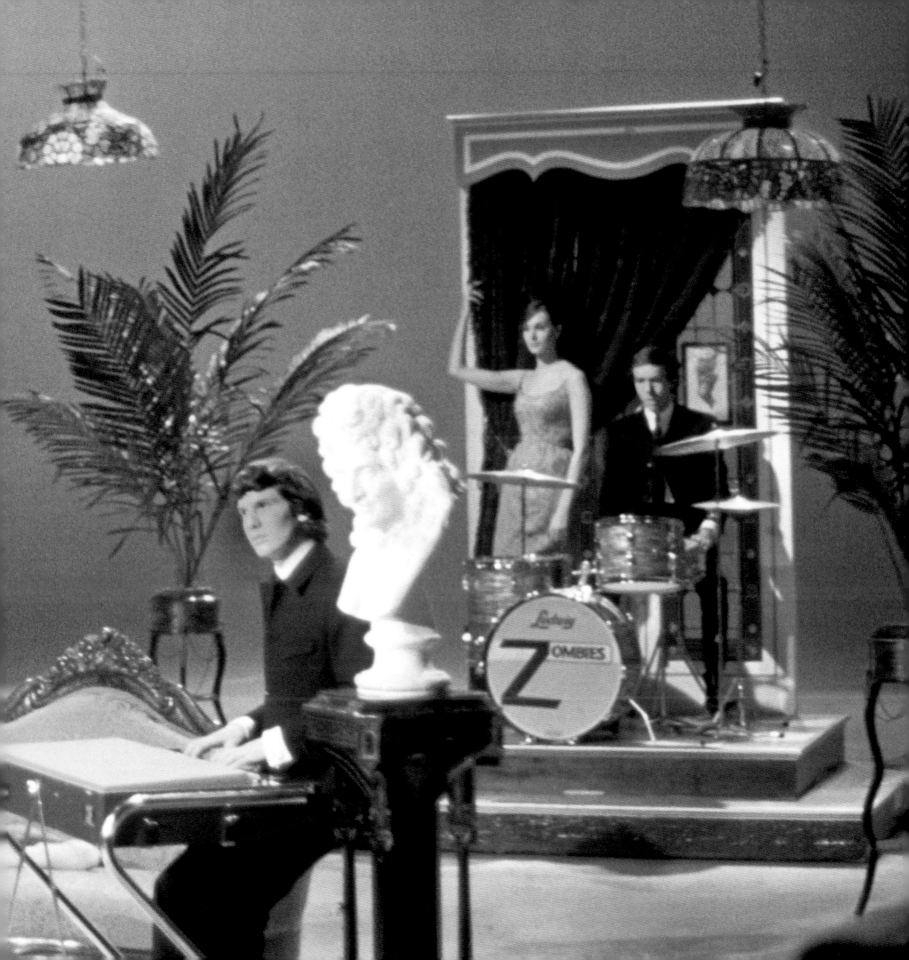

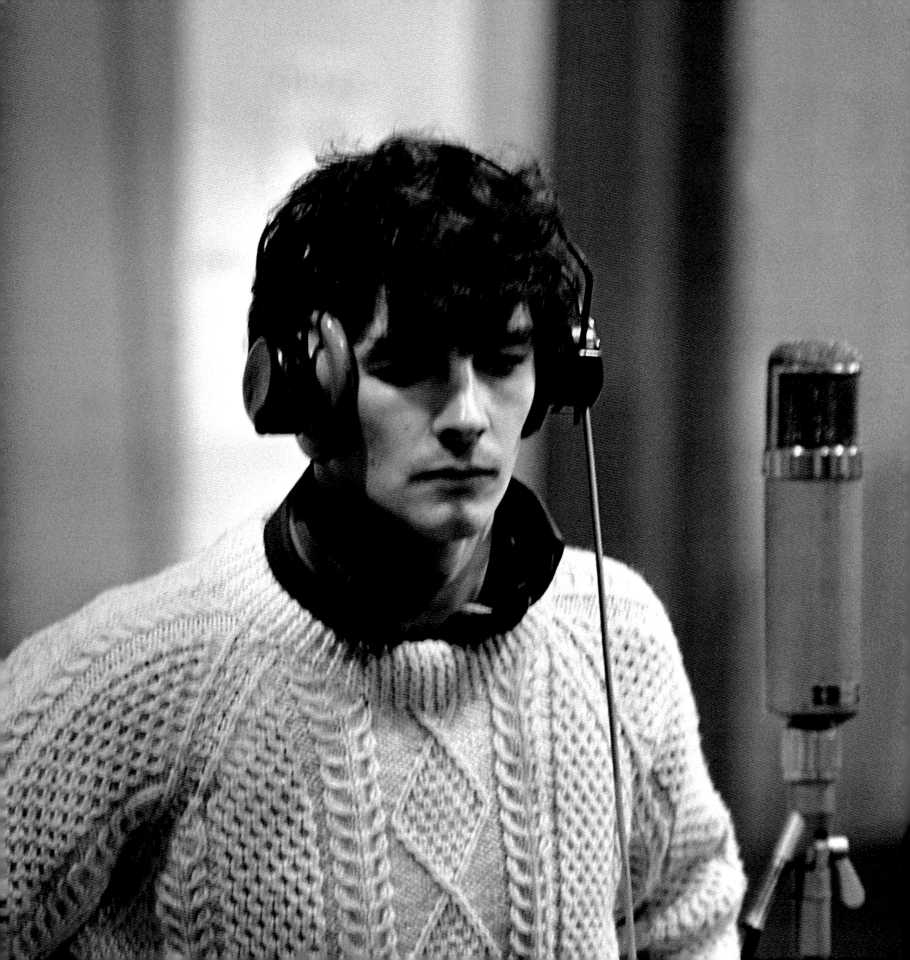

Odessey and Oracle: The Making of a Masterpiece, 1967-1969

By 1967, The Zombies' deal with Decca was complete. Wanting to produce themselves, they signed with the CBS label and started work on their second LP. Most of the tracks were recorded at Abbey Road Studios in London, where The Beatles had just finished work on their *Sgt. Pepper's Lonely Hearts Club Band* LP. Because they were working with a small budget there was no time to waste. The Zombies were well rehearsed and efficient during their studio sessions in the summer and fall of 1967. With access to new sonic textures such as the Mellotron, however, they made space for spontaneous enhancements to the basic tracks.

A couple of singles were released before the year was over, but failed to gain any traction with radio audiences. Discouraged, The Zombies had already broken up by the time the *Odessey and Oracle* album was released in the UK in the spring of 1968. It hit the US market in June, but the singles released to US radio were not a commercial success, either. In a last-ditch effort, "Time of the Season" was issued at the end of 1968. It hit the *Billboard* chart in February of 1969, climbing to the Top 5 in *Billboard* and #1 in *Cashbox* by the end of March. Sales were substantial, giving The Zombies their greatest commercial success well over a year after breaking up.

The band members decided not to re-form and the *Odessey and Oracle* album fell into obscurity. Diehard enthusiasts, however, continued to sing its praises, recognizing it as a lost 1960s masterpiece. *Rolling Stone* magazine ranked it at #100 on their list of the "500 Greatest Albums of All Time," while *Mojo* magazine similarly included it in their list of the "100 Greatest Albums Ever Made." Over the years, it has grown to be regarded as an absolute classic.

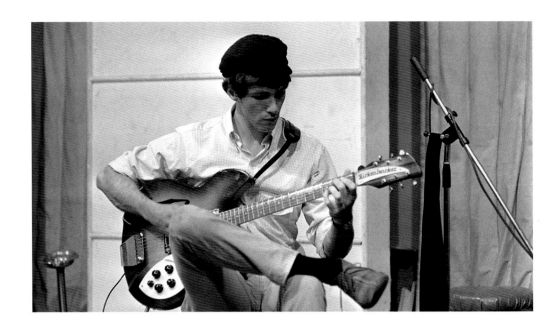

"It was breezy. That was my impression of The Zombies' music when I heard it playing on my green Westinghouse transistor radio in 1965. I was 12 years old when 'Tell Her No' came on WMCA in New York and I remember waiting to hear it again and again, until I bought my own copy. From that moment I was hooked on this band. When 'Time of the Season' came out roughly four years later, it defined the spring and the summer of 1969 with its swagger. I heard it on the radio when I was first learning to drive. I didn't know the name of the singer or any members of The Zombies. They were a singles band for me. I didn't own any of their albums, so I hadn't had the chance to memorize the liner notes, well not until this album, and this record blew my 16-year-old mind.

Odessey and Oracle stretched my imaginings of what rock music could be. I had this thing, this belief that rock was about the guitar. Having a keyboard as the lead instrument was something of my parents' generation, or perhaps much older '50s rock and roll. But unlike many of their British Invasion compatriots, The Zombies were more keyboard-based than guitar-based, and the melodies coming from those keyboards were undeniable. The organ solo on 'Time of the Season' was one of my gateways to jazz. And another of those rock stretching moments was the crazy opening beats with its snap and fizz. It's not your typical pop beat. And because it wasn't typical, this record endured where others would come to sound old and gimmicky. I love this album. I love its endurance, the way it wouldn't go away despite Columbia Records' indifference. I also love the way a generation of new listeners, 50 years later, find it enchanting and refreshing.

Bands want to be accepted and loved for the music they make, when they make it, but I think the most laudable moment in a musician's life is to grow old and still find love in subsequent generations. I see that pride when they play to fans these days, fans both old and young, moms and sons, fathers and daughters, it's pretty sweet."

- Bob Boilen, NPR's All Songs Considered

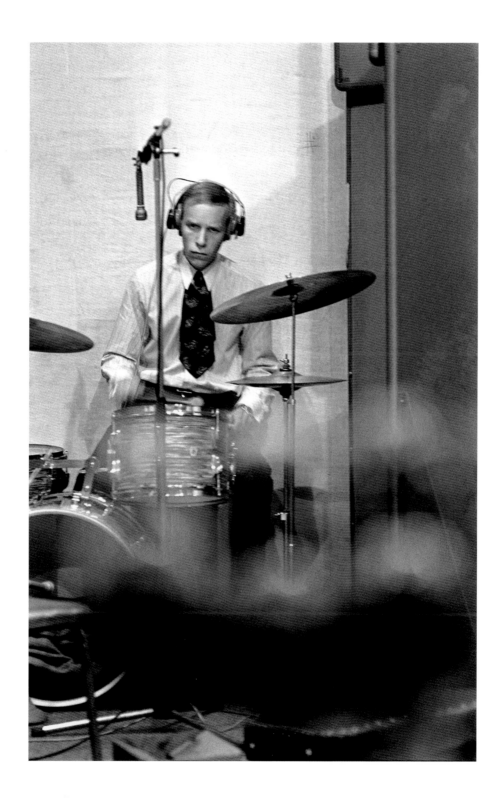

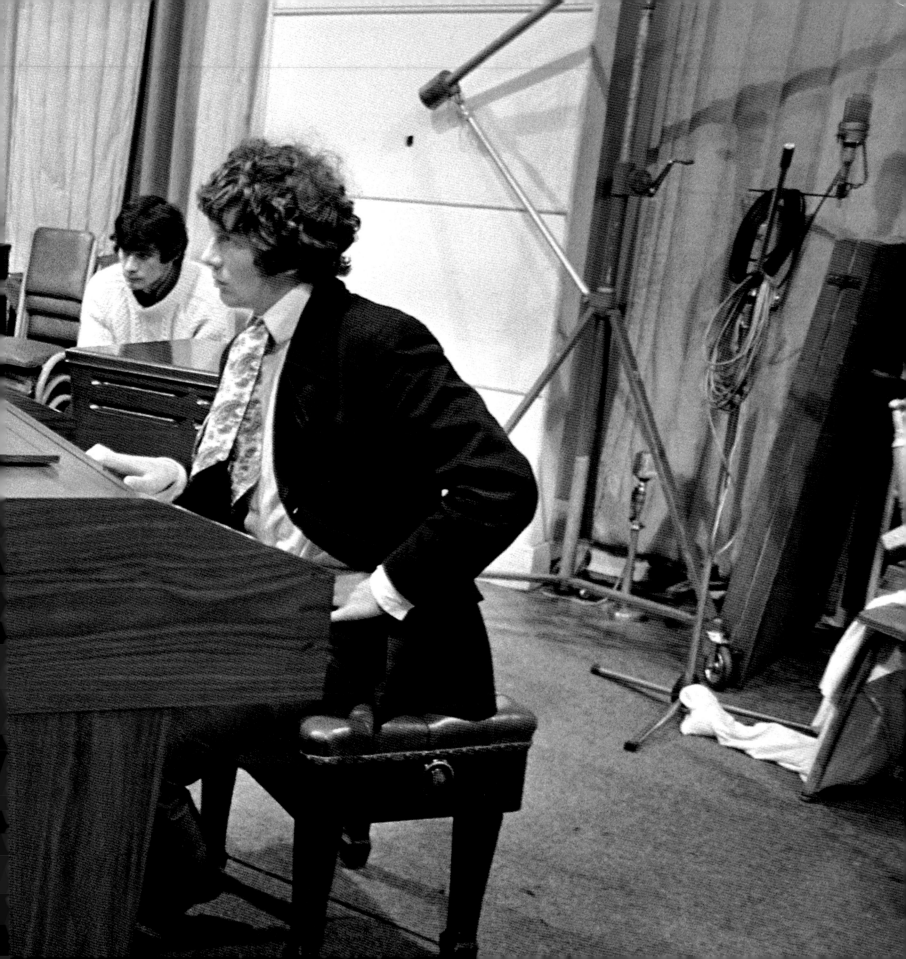

"When I first heard of The Zombies, the name immediately struck me. I thought this must be some cool new underground indie rock band. Later my Uncle Joe informed me that they had actually gotten their start in the '60s, which, truthfully, made them even cooler to my young teenage ears. Then he played me *Odessey and Oracle*, I was completely blown away. From that moment forward The Zombies became a standout obsession of mine. Everything from the quick-witted swagger in their lyrics, to the gorgeously adventurous melodies had me locked. Not to mention the groundbreaking sonics and instrumentation. Simply put, The Zombies have been one of the single most impactful groups on Cage The Elephant. Their music stands the test of time and, in my opinion, *Odessey and Oracle* is one of the greatest records ever made." - **Matt Shultz, Cage The Elephant**

"*Odessey and Oracle* is a timeless masterpiece. The chord progressions, vocal delivery, and instrumentation are amazing. Recorded in Abbey Road Studios by Mr. Geoff Emerick, The Zombies basically had all the same instruments and engineering as The Beatles. Song to song, it is an adventurous masterwork of one of the all-time greatest bands." - **Matthan Minster, Cage The Elephant**

Care Of Cell 44

Good morning to you, I hope you're feeling better, baby
Thinking of me while you are far away
Counting the days until they set you free again
Writing this letter hoping you're OK

Saved you the room you used to stay in every Sunday
The one that is warmed by sunshine every day
And we'll get to know each other for a second time
And then you can tell me 'bout your prison stay

 Mmm — mmm
Feel so good, you're coming home soon!

It's gonna be good to have you back again with me
Watching the laughter play around your eyes
Come up and fetch you, saved up for the train fare money
Kiss and make up and it will be so nice....

 Mmm — mmm
Feel so good, you're coming home soon!

 We'll walk in the way we used to walk
 And it could be so nice
 We'll talk in the way we used to talk
 And it could be so nice

It's gonna be good to have you back again with me
Watching the laughter play around your eyes
Come up and fetch you, saved up for the train fare money
Kiss and make up and it will be so nice...

 Mmm — mmm
Feel so good, you're coming home soon!
 Mmm — mmm
Feel so good, you're coming home soon

Rod Argent

Care of Cell 44
(Rod Argent)

"Quintessential English pop, the Rod Argent penned 'Care of Cell 44' is a timeless masterpiece, which sounds like it could have been written a thousand years ago or yesterday. Earmarked by a clever lyric written as a letter to a lover soon to be leaving prison ("feel so good, you're coming home soon…"), the song is an exquisitely crafted pop miniature built on jubilant sonic magic. 'Care of Cell 44' delivers a majestic baroque melody melding delectable layers of harpsichord and Mellotron, Chris White's swooping McCartney-like bass lines, transcendent chorale harmonies and the spectacular and inspired vocals of Colin Blunstone, making this jewel a classic *tour de force* for the ages." **- Ken Sharp, author and music journalist**

Chris: We only had a £1,000 budget, so we knew we had to be very well rehearsed. Recording at Abbey Road was done in strict three hour increments and we only had four tracks, so we had to put the songs down quickly and correctly. We really rehearsed before we went in. Then when we got in there and had access to the Mellotron and other instruments left around by The Beatles, we improved some things by changing them in the studio. But we went in with a basic plan that was sometimes altered along the way.

Rod: On "Care of Cell 44" I started with a little fragment of lyrics and spun a story from there. I had a little musical phrase that started with the opening bass line of the song. It felt jaunty and optimistic. I started writing, "Good morning to you, I hope you're feeling better, baby." That's all I had at first, but then I thought about taking a romantic and optimistic song and turning it on its head a bit to get a different angle. I got the idea of making it a letter to someone in prison who's excited about renewing their relationship.

Chris: When we started to rehearse new songs for the CBS record deal, I think this was one of the first songs Rod played to us standing around the piano in his parents' house. He came up with the great idea that it was a man writing to the girl in prison, not the other way around. It was originally called "Prison Song," and then "Care of Cell 69." It ended up as "Care of Cell 44" when it was retitled by the publisher in America so as not to offend anyone! I think Rod intended to be a little bit naughty with the title, but you'd really have to ask him.

Rod: Oh, yes, the title was done slightly tongue-in-cheek! But the song was really a beautiful story of acceptance. It was a time of non-judgment, and "Care of Cell 44" was written in that spirit, I suppose.

Colin: At the time this was probably my favorite track on the album. It has such a wonderfully original lyric and that super-catchy upbeat melody. I really thought this was the stand-out commercial track, but when it was released as a single it did absolutely nothing. I think that disappointment probably scarred me for life!

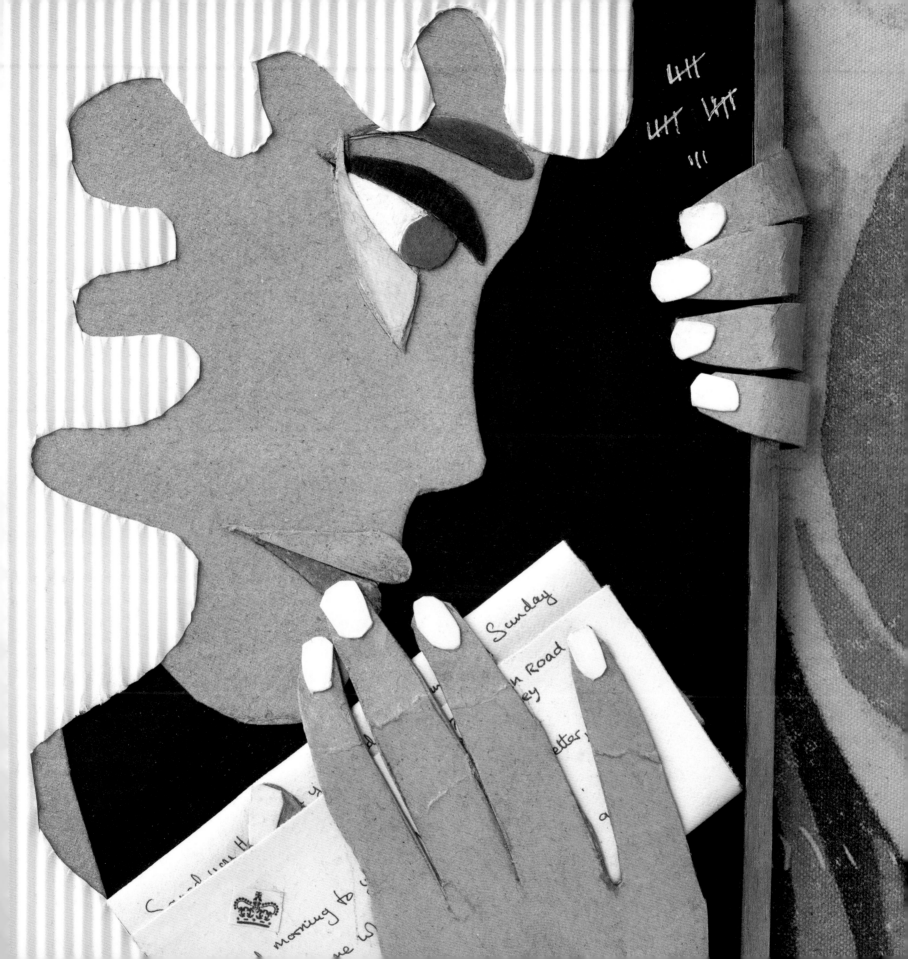

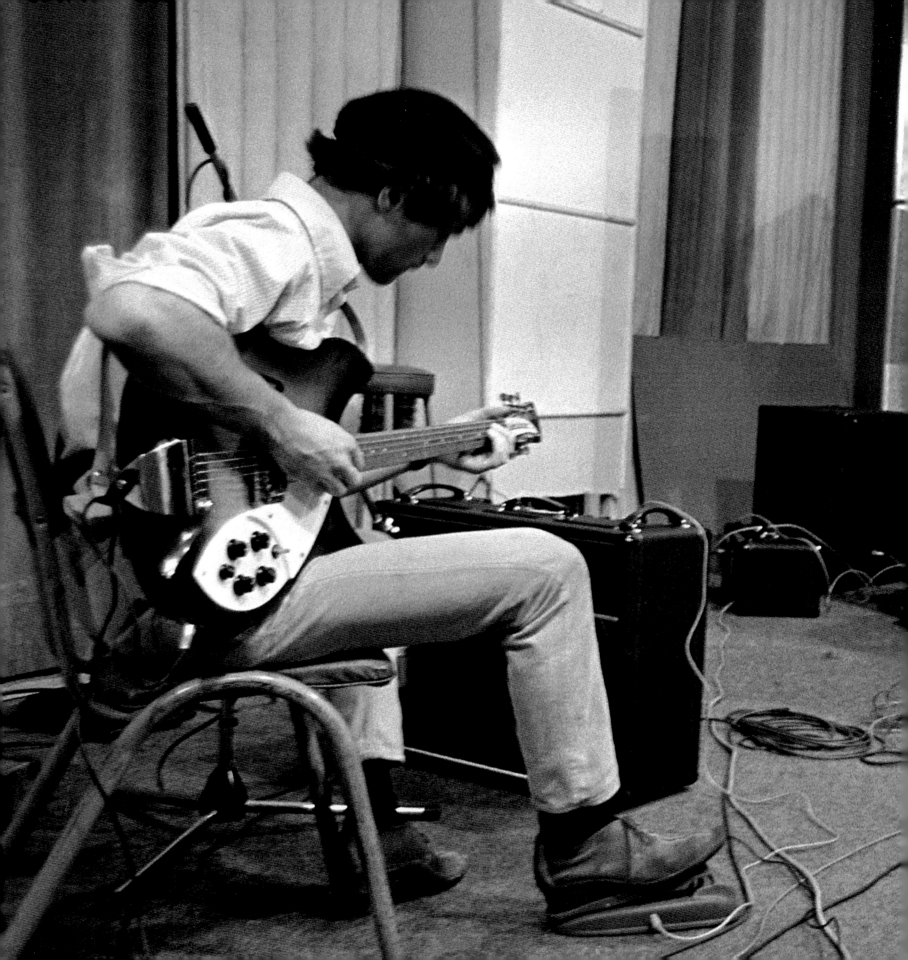

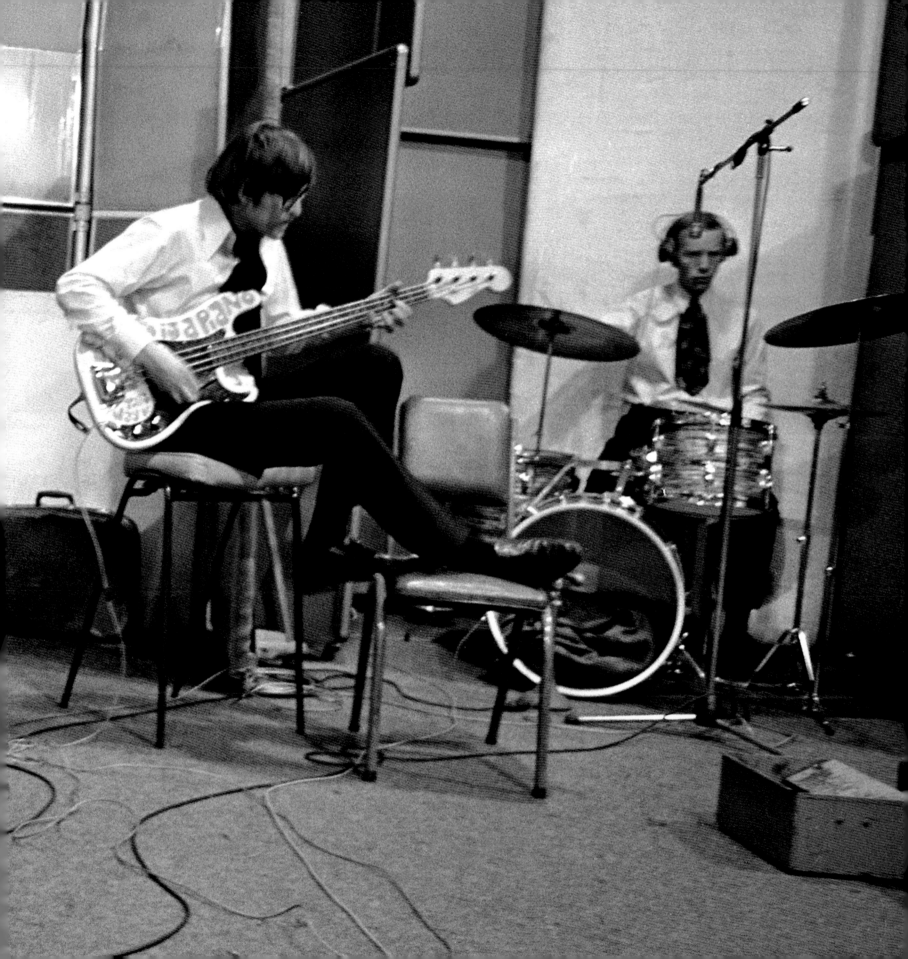

A Rose for Emily
(Rod Argent)

"I've loved The Zombies since I was a very young girl, sitting in the backseat of my mother's station wagon; and though their music played through a tinny car radio, its elegance, soulfulness, myriad magical textures, and foggy London intrigue found me on the sunshiny, palm-lined streets of Los Angeles.

It wasn't until I began recording with Matthew Sweet, in 2005, that I discovered the masterpiece, *Odessey and Oracle*; I was painfully late to the party, but the thing is, I've never left – still drunk with love for this record. Which leads me to my obsession with 'A Rose for Emily'; I listen to it nearly every morning on those same sunny palm-lined streets, now through an iPhone.

'A Rose for Emily': the incandescent melody, heartrending lyric, lacework arrangement – the tone and timbre of Colin's wondrous voice, dissolving one syllable to the next, in textures of silk and velvet and linen, all conspire to thrill and move you. The song is a lesson in craft and excellence and wonder – it defies the laws of physics – reaches through space and time and touches you, so you actually feel it tingle on your skin.

I am profoundly grateful to call the members of The Zombies my friends and to have had the great honor of singing their gorgeous songs." *- Susanna Hoffs*

A Rose For Emily

Though summer is here at last
 The sky is overcast
And no-one brings a rose for Emily

She watches her flowers grow
 While lovers come and go
To give each other roses from her tree
 But not a rose for Emily

 Emily, can't you see
 There's nothing you can do?
 There's loving everywhere
 But none for you...

Her roses are fading now
 She keeps her pride somehow
That's all she has protecting her from pain

And as the years go by
She will grow old and die
The roses in her garden fade away
Not one left for her grave
Not a rose for Emily

 Emily, can't you see
There's nothing you can do?
There's loving every where
But none for you....

Rod Argent

while lovers come and go

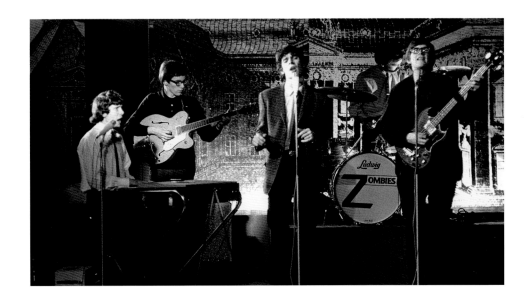

Chris: We rehearsed very thoroughly before we went in the studio. It cost a lot to go to the studio, so we were very careful.

Rod: We didn't have much money, so *Odessey and Oracle* was recorded over the period of a year in short three or four hour sessions. I remember we were recording the songs as we were writing them. We would write a couple of songs, rehearse them really thoroughly, then go in and record them. We got to the point where I thought I should be writing more songs because it was taking a lot of time to get through the process. I remember being at my parents' house and I wrote a little note to myself that said, "Tomorrow morning, 9 o'clock: get up; 9:30: write a song." I went downstairs and I thought, "Where am I going to start?"

Chris: Book titles are often an inspiration for songwriters. Rod was inspired by seeing a William Faulkner short story title called "A Rose for Emily." That title developed into this beautiful track.

Rod: My song had nothing to do with the story, but I thought the title was really evocative, so I started to spin a story around those words. I then wrote the melody and the chords, and the whole thing was done in a day. I was really pleased with it. It was one of those songs that came quickly, fell into place, and almost wrote itself. I ended the day with a song that I was really happy with.

Colin: This is such a beautifully simple song. I spent a lot of time with Rod working on the vocal phrasing so I could get it just right for the recording.

Hugh: Rod was quite right in his arrangement of this very beautiful song. It makes me shiver every time I hear it.

Maybe After He's Gone

She told me she loved me
With words as soft as morning rain
But the light that fell upon me
Turned to shadow when he came

Chorus: Maybe after He's gone
 She'll come back – love me again
 Maybe after He's gone
 She'll come back – want me again

I remember joy and pain
Her smile, her tears are part of me
I feel I'll never breathe again
I feel life's gone from me

 Chorus

 All the days and all the nights
 Are time just passing by
 And all the dreams I'm dreaming now
 Hide the tears that I cry

I feel so cold
I'm on my own
As the night folds in around me
Night surrounds me, I'm alone
 Chorus

Chris White

Maybe After He's Gone

(Chris White)

"If the sub-text of *Odessey and Oracle* is concerned with the loss of innocence and its accompanying, somewhat yearning, sadness, then Chris White's 'Maybe After He's Gone' is as good an example of any of The Zombies' unique ability to translate such emotions into notes, words, and sound. It had begun in a much more plaintive fashion as 'One Day I'll Say Goodbye,' one of a brace of new tunes that Rod, Chris, and Colin had woodshedded upon in the autumn of 1966. The verses of that early incarnation would eventually provide the melodic thrust of the chorus in 'Maybe After He's Gone,' lending a pitifully expectant respite to this bittersweet reminiscence of unfulfilled romance. One of three tracks on the album recorded not at Abbey Road but the Stones-favored Olympic Studios in South London, the somber beauty of 'Maybe After He's Gone' remains one of the album's emotional pinnacles, emphasized in particular by the cascading intervals upon its culmination. Rarely in pop music have hope and despondency been represented as harmoniously and effectively as they are within *Odessey and Oracle*."

- Alec Palao, reissue producer, compiler of the Zombie Heaven box set.

night surrounds me I'm alone

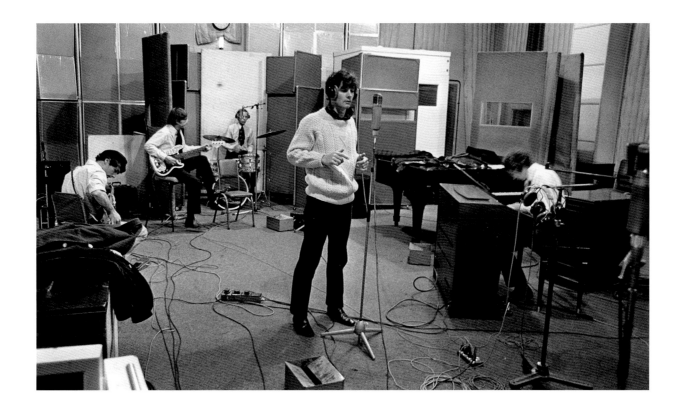

Chris: This is one of those typical lost love songs. Jealousy? It's not worth it! It all works out OK in the end, especially when we can all join with the harmonies. When one writes, you write what you know about, but my songs were more vignettes, or little stories to be told. They weren't autobiographical.

Colin: As I remember it, there was an edit in the closing choruses that makes this quite a difficult song to replicate live. Though I also remember someone else saying there wasn't an edit. The other guys and I sometimes marvel at how time can result in people remembering things differently!

Chris: You'll get stories from one of us, but they're slightly different because we all remember things differently.

Rod: I can't remember anything about recording "Maybe After He's Gone" except that this was the first time we had extra tracks. We would go in and were very well rehearsed. We'd put down what we rehearsed thoroughly, but since we were now utilizing a couple of four-track machines, we'd listen to what we'd done and get inspired to use some of the extra tracks for harmonies or a Mellotron or something like that. My memory is that it was John Lennon's Mellotron that was left in the studio. They hadn't picked it up. Without asking anybody we just used it! The bit at the end of "Maybe After He's Gone" where the vocals all overlap was done by mechanical process in terms of overdubbing. We had techniques that hadn't been available to us before, and we were eager to experiment!

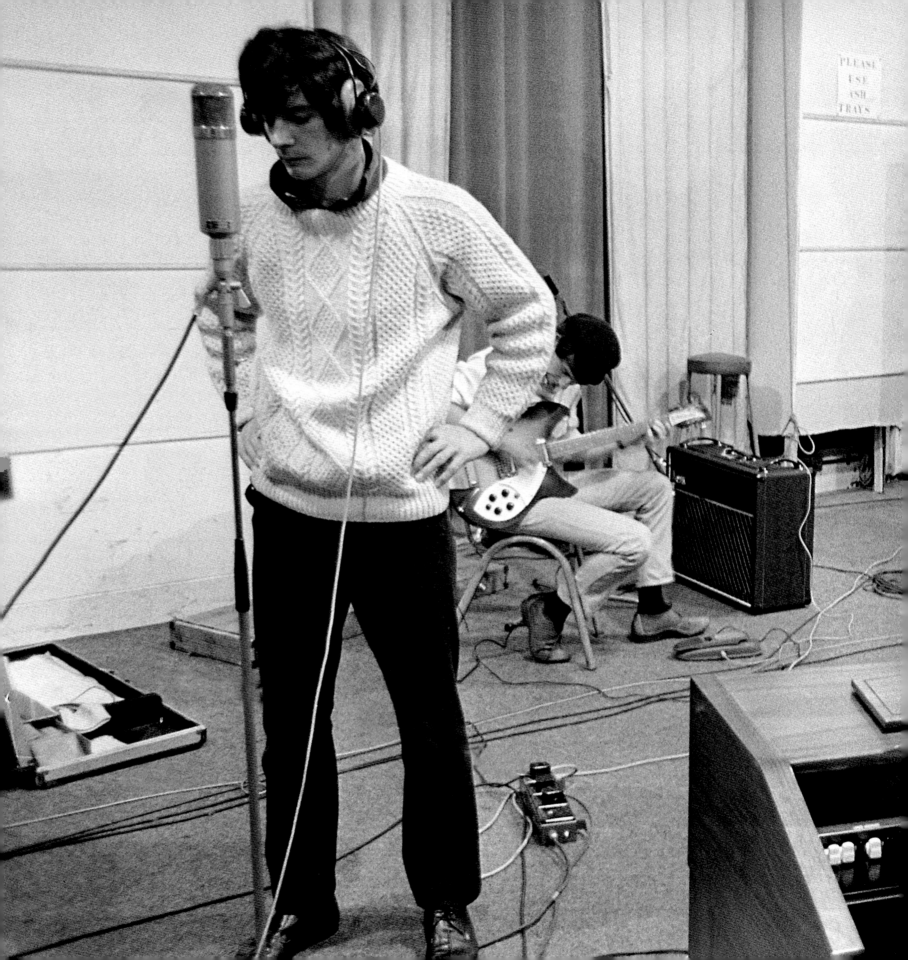

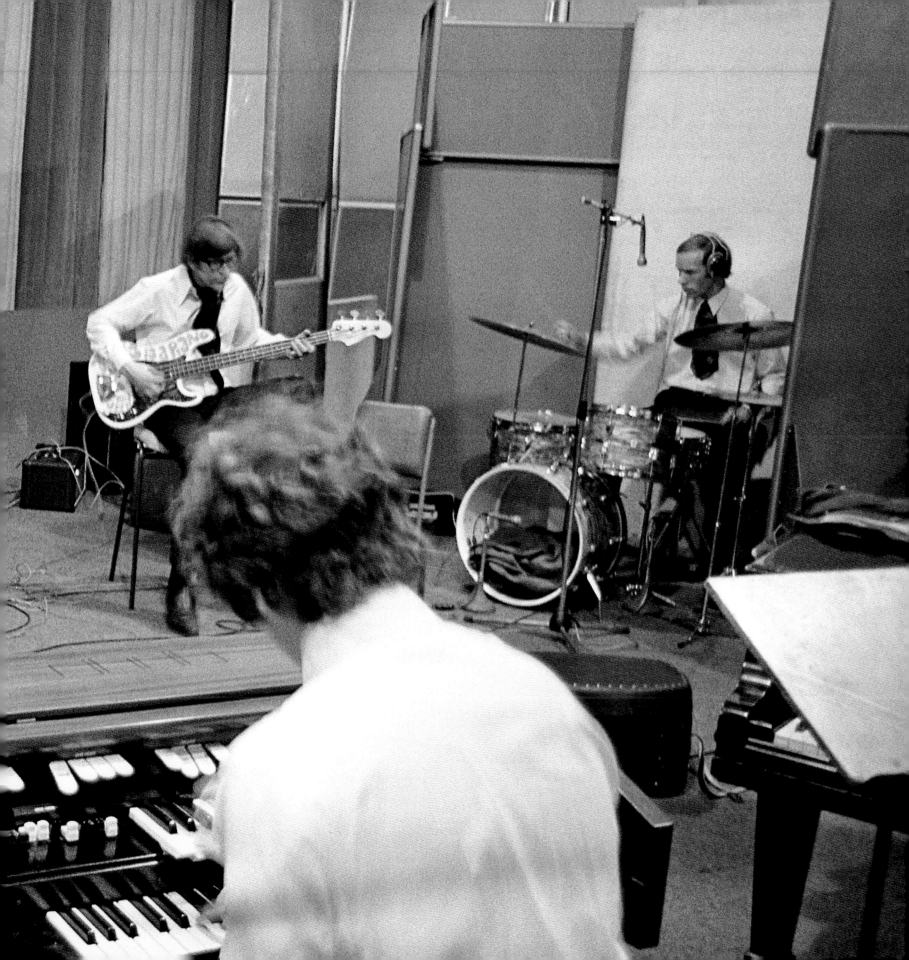

Beechwood Park

(Chris White)

"*Odessey and Oracle* for me is like a suite, so it's difficult to single out my favorite track; but if I had to, I'd go for 'Beechwood Park.' When I first heard this incredible album, it was part of a great reissue called *Time of the Zombies* (wicked sleeve too!), so it would have been mid '70s. My best mate, Steve Brookes, had just bought it and so I went over to his house to hear it.

It was late September/early October time and Steve's flat faced onto Woking Park. It was a bright and sunny day and the leaves were changing color in their wonderful way. For me, there's a weird nostalgic feeling around that time of year. Maybe the thought of summer gone and the prospect of dark, short days to come and the cold of winter. The whole of *Odessey* has a nostalgic, wistful vibe on it – a sense of "loss," a yearning for a better time. They are feelings inherently English; they are in a lot of great English music, from Ray Davies to Maurice Ravel to Pete Doherty and on...

Me and Steve had met at school when we were 14 and pretty much started a band at the same time. Man, we were close; wrote songs together, learnt and played guitar together, got drunk together. We were inseparable. But we had started to drift apart, both moving in different directions, growing up or down, whatever. But it certainly hurt and I missed our friendship and our vision of what we would do with our own band one day. Such is life.

'Beechwood Park' captures all those feelings for me. In its longing for happier times, the loss of innocence, and the pain of knowing those times are gone forever. This beautiful song will always hold these feelings and memories for me, indeed the whole album does.

Thank you Rod, Colin, Chris, Hugh, and Paul for touching my life with your beautiful music. I'm so glad the world finally woke up to what you all achieved all those years ago. This record will last forever." - *Paul Weller*

Beechwood Park

Do you remember summer days
Just after summer rain
When all the air was damp and warm
In the green of country lanes

Chorus

And the breeze would take your hair
Kiss your face and make you care
About your world
Your summer world
And we would count the evening stars
As the days grew dark — in Beechwood Park

Do you remember golden days
And golden summer sun
The sound of laughter in our ears
And the breeze as we would run

Chorus

All roads in my mind
Take me back in my mind
And I can't forget you
Won't forget you
Won't forget those days — and Beechwood Park

Chris White

Chris: I had written that song when we were touring in the Philippines. It was a memory of a place that was near where I lived as a kid. My father had a small village shop and I used to help him deliver groceries to this private girls' school, which was in an old manor house in a private country estate. The lanes and hedgerows that surrounded the grounds were typically and gloriously English. I remember driving down those lanes as the steam rose up off the tarmac as the warm summer sun came out after the rain. And you see so many stars in that clear country air! It was very much a nostalgic kind of song.

Rod: When Chris played me the song I absolutely loved it. His songwriting really flowered around that time and I loved everything he was doing. I loved that it was written around an early teenage experience. My memory is that it was my idea to give it a mood with the slow organ. This was soon after "Whiter Shade of Pale" came out and, even though it doesn't sound like that song at all, I was inspired to give it some of that kind of moodiness.

Colin: Because the Abbey Road studio was so popular we had to record the basic tracks for "Beechwood Park," "Maybe After He's Gone," and "I Want Her, She Wants Me" at Olympic Studios in Barnes. I was quite concerned at the time that these three tracks would have a different sonic quality and might not fit in with the sound of the rest of the album. Our wonderful engineers, Peter Vince and Geoff Emerick, laid all my fears to rest.

Rod: It has a very different sound to my ears and a different mood because of the different studio and different engineer.

Chris: Coincidently, Beechwood Park was where the prison camp scene in *The Dirty Dozen* was filmed. It was also a place where Henry VIII and Edward VII would visit, so it was quite an interesting place.

Colin: The owner of the actual Beechwood Park got very upset that the name of their park was used without permission. It sounds to me like they had too much time on their hands!

... and we would count the evening stars ...

Brief Candles
(Chris White)

"It was very hard for us to choose any one song from *Odessey and Oracle* to write about. The entire album is so good and each song contributes to the whole of the feeling. We chose 'Brief Candles' because it seems like a microcosm of the album's style, themes, and aesthetics. Often, the songs on this record describe something in the third person, and this one abstractly describes a number of scenes where people sift through heartbreak. This occurs over the song's beautiful piano section. This part alone could make a great song, with its lovely winding melody, double tracked perfectly. That section gives way to an energetic chorus where the odd, poignant title 'Brief Candles' is introduced, and this, in turn, slides into another melodic section where the big message of the song is revealed: '...his sadness makes him smile...' The way each section is linked through lyric, melody, and arrangement is masterful. The vocal harmonies are powerful, yet subtle so it doesn't ever feel like showing off. After two times through the sections, an imaginative, lyric-less little bridge occurs and takes you back to the beginning. This seamless arrangement and the way each section is strong enough to be its own song typify this entire record. Even after listening to *Odessey and Oracle* countless times, we still find it vivid and meaningful." - *Beach House*

Brief Candles

There she sits, her hands are held
Tight around her glass
She only needs to be alone
She knows this mood will pass
To realise that she was strong
And he too weak to stay
And to realise that she is better off this way

> Brief candles in her mind
> Bright and tiny gems of memory
> Brief candles burn so fine
> Leaves a light inside where she/he can see
> What makes it all worthwhile
> Her/his sadness makes her smile

He's alone, girl fades away
Left out on a limb
Finds he needs her more because
She's no more need of him
He understood so very well - the things she had to say
Soon he'll understand that he's better off this way

Chorus

In the corner, see his face
A man just sips his drink
Not one feeling does he show - far too numb to think
He does not say a single word - no word of love to stay
Maybe he will soon believe he's better off this way

Chorus

Chris White

Chris: Book titles again! I wanted to write about a scene set in a bar, with several separate, lonely people drinking and musing over bittersweet memories. I saw the title of a book of short stories by Aldous Huxley and knew that his title summed up the atmosphere of the whole song. There's no copyright on titles, so I thought, "Oh, that's a good one!" We decided to have each story told by three different singers, which worked out really well.

Colin: This is the only song on which Rod, Chris, and I all sang the lead vocal on a verse. I think it works perfectly.

Chris: Splitting up the verses was a way to emphasize each character's isolation.

Rod: "Brief Candles" has a sort of baroque classical feeling in the middle of it, which was quite unusual. My mom got me involved in a fantastic choir when I was about 11 years old, which opened my eyes to so much classical music. I loved it. Almost immediately after that I heard Elvis, so my world was spun around. I was listening to Elvis and Little Richard and Jerry Lee Lewis while being completely knocked out with Stravinsky and Bach. I was also being blown away by hearing Miles Davis and Bill Evans. I didn't see any difference, which sounds crazy, but if something works, it's water from the same well, in a way. A track like "Brief Candles" doesn't sound like other bands of that era to me, and I'm proud of that distinction.

Chris: It was a group decision when it came to selecting material to record. We turned up at rehearsal with different songs and played over them and developed them. Primarily Rod was the main mover, because he was the leader of the group. If he didn't like it, it probably wouldn't go in, but he was willing to try many things.

Hung Up On A Dream

Well, I remember yesterday
Just drifting slowly through a crowded street
With neon darkness shimmering through the haze
A sea of faces rippling in the heat

And from that nameless, changing crowd
A sweet vibration seemed to fill the air
I stood astounded, staring hard
At men with flowers resting in their hair

A sweet confusion filled my mind
Until I woke up, only finding
Everything was just a dream
A dream unusual of its kind
That gave me peace and blew my mind
And now I'm hung up on a dream

They spoke with soft persuading words
About a living creed of gentle love
And turned me on to sounds unheard
And showed me strangest clouded sights above

Which gently touched my aching mind
And soothed the wanderings of my troubled brain
Sometimes I think I'll never find
Such purity and peace of mind again

Rod Argent

Hung Up on a Dream
(Rod Argent)

"Growing up, I'd always heard and enjoyed 'Time of the Season' on the radio (who hasn't?), but just assumed The Zombies were a 'one hit wonder' psychedelic band. In my early 20s, when I was really getting into writing music, someone turned me on to *Odessey and Oracle*. My life changed. I pretty much listened to nothing else for an entire year. From the second those insanely aggressive yet soothing harmonies hit on 'Care of Cell 44,' I was hooked. I sang 'This Will Be Our Year' as my sister walked down the aisle at her wedding. And I'm always compelled to feel something deep down whenever I hear the beat kick back in on 'Hung Up on a Dream.' Couple that with the way Colin sings "sometimes I think I'll never find..." and you've got a song I could never duplicate, no matter how hard I try. I can't count the amount of people I've turned on to this album. And, in my opinion, *Odessey and Oracle* is as good as anything I've ever heard – and is getting better with age. *- Nate Ruess, fun.*

"'Hung Up on a Dream' really exemplifies the feeling of *Odessey* to me. Probably my favorite musical arrangements on the album. I love the way that the musical melodies and hooks match the vocals almost as a call and response, like punctuation would be used. Just brilliant." *- Nick Bockrath, Cage The Elephant*

Colin: This is another one of my favorite tracks from *Odessey and Oracle*. There is such great imagery in the lyric, and what a haunting melody!

Rod: This song is a little trippy, but psychedelic drugs weren't a factor for us at all. Most people weren't aware of the album until 1969, which was kind of a peak year for drug experimentation, but it was actually recorded in 1967. We were only just starting to be aware of those things then. We were recording the album and breaking up, so we weren't around and weren't really exposed to drugs like some other bands. I often wonder if we were saved from some of those things. It always felt a little bit crude to me to rely on drugs when it came to creativity. It was an undeniable effect, but it felt like, temperamentally, I wasn't particularly attracted to drugs. I never disapproved of other people experimenting, but it just wasn't really for me.

Chris: "Hung Up on a Dream" is one of my favorite Rod Argent songs. It was written at the time of the Summer of Love. We had great hopes that the movement would develop into more. It was a time when it was possible to envision that the power of universal love might be extended to all. It wasn't. It didn't. It crashed in a fog of drugs and exploitation. Maybe it will happen one day.

Rod: In spite of not being influenced by psychedelic drugs, we were very much affected by the climate of the times. Even though we were aware of some of the naiveté of it, there was something magical about that era. At its best it really seemed like a time when youth culture made a difference in the world. Real change seemed possible, and it was happening. That spirit affected the atmosphere of some of the lyrics we were writing. I'm very fond of the lyrics, except for a couple of phrases. The one with "men with flowers resting in their hair" used to make me cringe a little bit, but generally, parts of that song are some of my favorite lyrical writing. The whole album was affected by the tenor of the times. It was a time of great experimentation, but great positivity that things really were changing.

Chris: This song has really grown on me over the years, which came about from playing it live. It's so fun to play. It was only four tracks originally, bounced down to another four-track machine with some enhancements added. You don't hear it the way it sounds live when you're playing the record because Rod added Mellotron and we had harmonies on it. But when we played it onstage it really stuck out in my mind. Playing it live allowed it to breathe and take on a whole life of its own.

Changes

I knew her when Summer was her crown
And Autumn sad, how brown her eyes
 Now see her walk by, peppermint coat
 Buttoned down clothes, buttoned up high
 Diamonds and stones hang from her hand
 Isn't she smart, isn't she grand

Chorus: I knew her when Summer was her crown
 And Autumn sad, how brown her eyes
 I knew her when Winter was her cloak
 And Spring her voice, she spoke to me

Now silver and gold, strawberry clothes
Money will buy something to hold
See in her eyes, nothing will last
Like emerald stones and platinum clasps.

Chorus I knew her when Summer

Chris White

Changes

(Chris White)

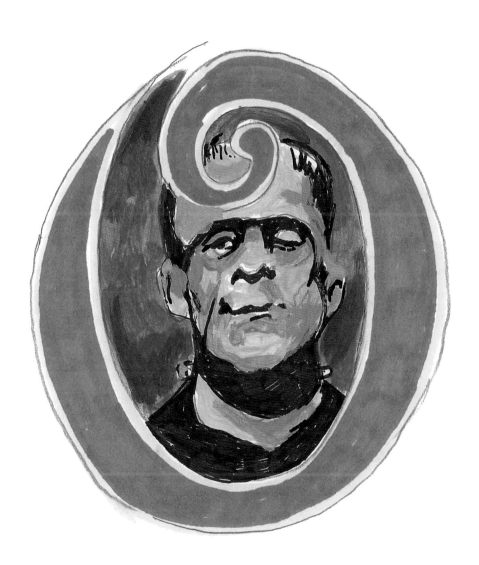

Chris: "Changes" is a song about the tendency to change from innocence to materialism. I think we're all pretty well-grounded, so this was just another story. You make up a story about some poor fellow who's seeing a girl and he's a nature's child, a hippy, and he's getting ideas about money and jewelry and fashion and things like that. It wasn't a personal experience. It was just observational. From the start, we knew this would work as a semi-acoustic number. The Mellotron and Rod's high vocal line complete the picture.

Rod: We didn't want a traditional drum track. We wanted to use sounds and make it more experimental. That track might have been slightly influenced by the fact that when we heard *Pet Sounds* we, like everyone else, were completely knocked out by it. We loved that Brian Wilson used unusual textures and rhythm section ideas that weren't just traditional drums. We put together a percussion track in the studio quite quickly with finger cymbals and various other things.

Colin: I think this was the only track we ever recorded that featured everyone in the band singing harmonies together.

Hugh: They allowed me, bless them, to take a vocal. Paul and I sang a bass line in unison. So, here I am onstage singing now. I never thought I'd ever be doing that!

Colin: Abbey Road had a very strict time limit on sessions, especially in Studio 3 where we recorded. It wasn't particularly well sound-proofed, and the neighbors used to complain! Everyone in Studio 3 recorded on a strict schedule of sessions from 10 a.m to 1 p.m.; 2 p.m. to 5 p.m.; and 7 p.m. to 10 p.m. I will always remember when we were recording "Changes" and were all gathered around a microphone. We were running out of time on the session. Even though we had the red recording light on, once we went one minute over our allotted time, two guys in long brown coats burst into the studio and moved the piano that was standing right next to us. We ignored them and just kept going! Although I think we may have recorded another take, I'd like to believe that somewhere in the backing vocal track there is the sound of men in long brown coats moving a huge concert grand piano.

Chris: Those who have good ears may be able to hear them. We were out of time and had to use the take.

Hugh: About seven years ago we all went to Rod's house. We got around a piano and sang "Changes." It sounded like we'd never been away. It sounded like the day before was just a typical day in the '60s and we'd just said, "Let's get together tomorrow and rehearse some songs." That was really special.

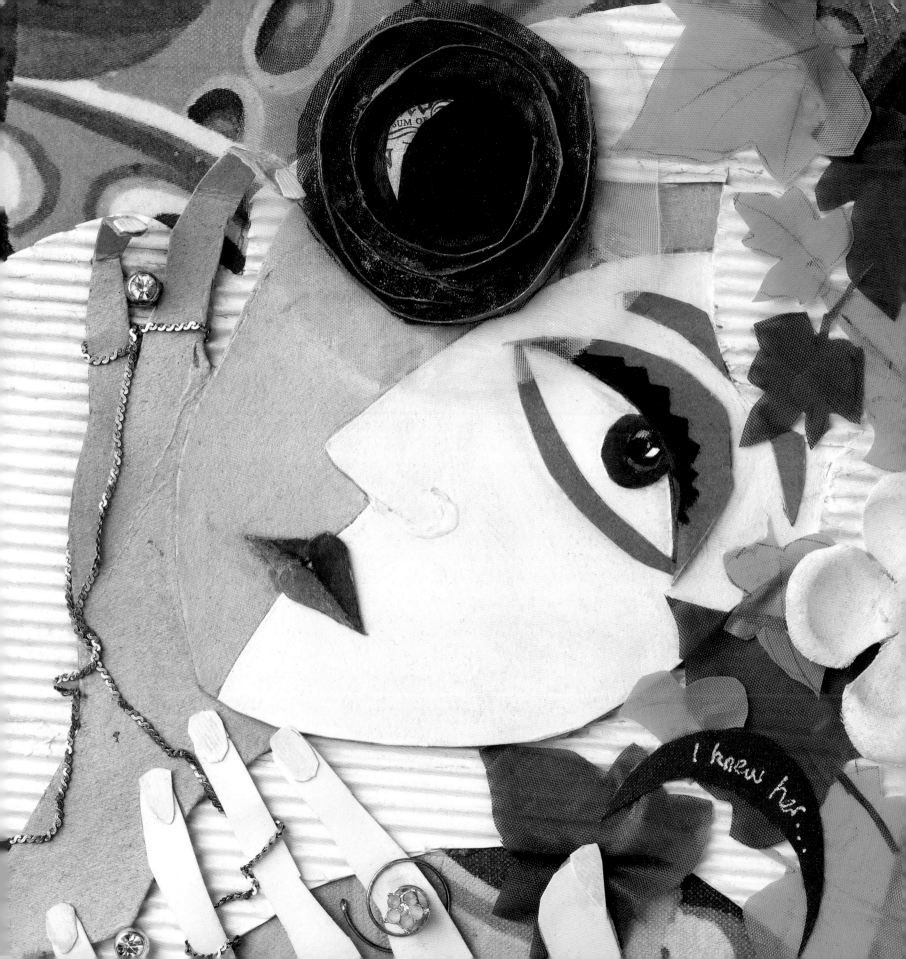

I Want Her, She Wants Me
(Rod Argent)

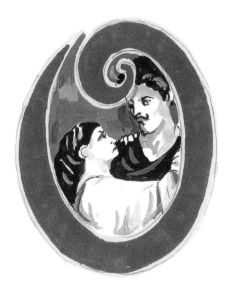

"'I Want Her She Wants Me' has been a staple on every mix tape I've ever made for a girl I've had a crush on."
- ***Nate Ruess, fun.***

Chris: Our music publishers were Joe Roncoroni and Ken Jones. We kept recording demos of songs, and they said someone from The Mindbenders' camp was looking for material. Joe sent some along and they picked up "I Want Her, She Wants Me."

Rod: I love The Mindbenders and think they're terrific, but they missed a couple of subtleties in the chord changes.

Chris: Rod didn't like the changes they made to the chord structure. He was very particular about the right chords, so we recorded it ourselves for *Odessey and Oracle*. Ours was much better because it was done the way it was originally intended to be performed.

Colin: I don't think I had too much to do with this particular track. Rod had already recorded the lead vocal, but I was asked to add a vocal on the choruses.

Rod: We recorded that with a harpsichord, but I prefer playing it onstage now with a piano sound instead of a harpsichord. That approach sounds a little more substantial to my ears.

I Want Her, She Wants Me

I close my eyes and soon I'm feeling sleepy
 I sleep so easy
There's nothing on my mind
 And life seems kind now
I want her she wants me

I walk downtown and as I look around me
All around me
The people smile at me
It's plain to see that
I want her, she wants me

She told me to be careful if I loved her (ooh)
 'Cause she had given her heart once before

And now she knows she doesn't have to worry
I would not make her sorry
There's nothing on her mind
And life seems kind now
I want her she wants me

She told me to be careful if I loved her (ooh)
'Cause she had given her heart once before

And now she knows she doesn't have to worry
I would not make her sorry
 There's nothing on her mind
 And life seems kind now

I want her, she wants me
I want her, she wants me (repeat 'til fade)

Rod Argent

This will be Our Year

The warmth of your love's
Like the warmth of the sun
And this will be our year
Took a long time to come
Don't let go of my hand
Now the Darkness has gone
For this will be our year
Took a long time to come

Chorus: And I won't forget
The way you helped me up when I was down
And I won't forget the way you said
"Darling I love you"
You gave me faith to go on
Now we're there and we've only just begun
This will be our year — took a long time to come

The warmth of your smile
Smile for me, little one
And this will be our year
Took a long time to come
You don't have to worry
All your worry days are gone
And this will be our year
Took a long time to come

Chorus

.. And this will be our year
Took a long time to come

Chris White

This Will Be Our Year

(Chris White)

"I saw The Zombies in concert in Kent, Ohio recently and was mightily impressed. There is one song, amongst many, that resonated with me, and it is 'This Will Be Our Year.' It's a perfect song to be played at any wedding, or at any gathering. From one songwriter to another, 'Well done!'" - *Graham Nash*

"On an album filled with so many inventive changes and harmonies, 'This Will Be Our Year' stands out simply and powerfully, showcasing both Rod's commanding piano and Colin's always magical voice in stark single and double track, harmony free. The swing, that addictive *O and O* Zombies feel, rolls it around and around in lilting pleasure. I just love it! When the lyric that finishes the bridge, 'Darling I love you, you gave me strength to go on' comes by, in a song so hopeful in its clear confidence in the future, so thankful for the support and love of another, it always gives me a warm positive feeling in my heart. Like the song says, it helps me up when I'm down, and 'I won't forget...'"
- *Matthew Sweet*

Colin: "This Will Be Our Year" is a song of enduring beauty and optimism that, over the years, has become one of the most popular tracks on the album.

Chris: This is one of those songs that has been performed at many a wedding. In fact, I have sung it myself at a couple of family weddings by request. The inspiration for that song was hope. It's quite a simple song, but it was a reflection of the belief that everything will turn out right.

Rod: "This Will Be Our Year" is a perfectly simple song with a beautiful sentiment. It's a lovely melody that just worked right from the beginning. After we recorded it Chris said, "I'd love to hear a brass band thing on this, kind of like a Salvation Army thing." Even though we parted ways with Ken Jones to be our own producers, we were still friends with him. Chris asked him to write an arrangement for the horns, which worked out wonderfully.

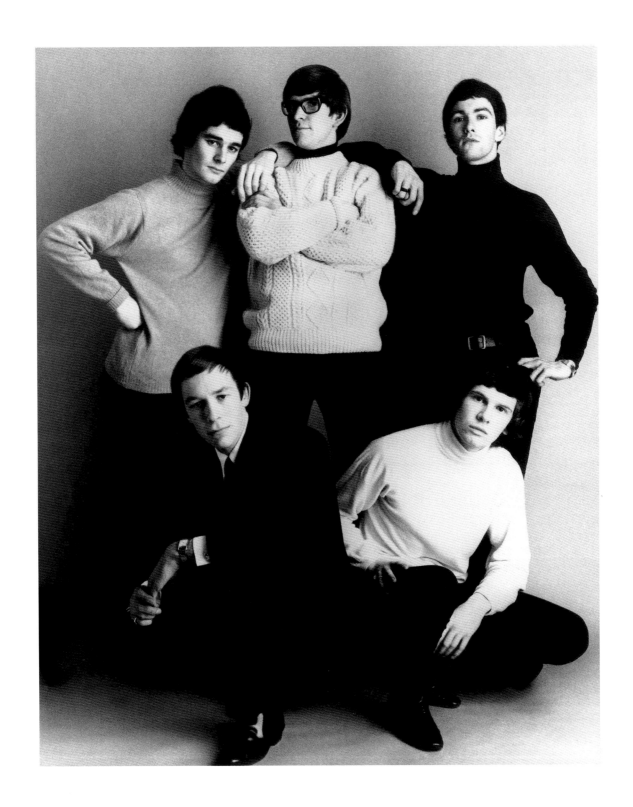

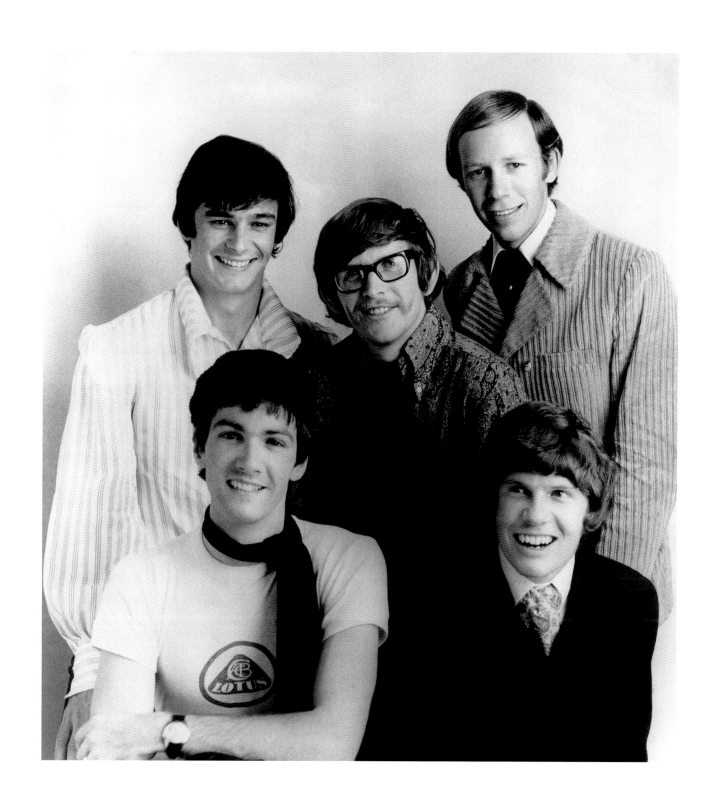

Butcher's Tale

A butcher, yes that was my trade
But the King's shilling is now my fee
A butcher I may as well have stayed
For the slaughter that I see

And the preacher in his pulpit
Sermoned 'Go and fight, do what is right'
But he don't have to hear these guns
And I bet he sleeps at night — And 1-1- 1

And I can't stop shaking — My hands won't stop shaking
My arms won't stop shaking — My mind won't stop shaking
I want to go home — please let me go home
Go home

And I have seen a friend of mine
Hang on the wire like some rag toy
And in the heat the flies came down
And cover up the boy

And the flies came down in Gommecourt,
Thiepval, Mametz Wood and French Verdun
If the preacher he could see those flies
Wouldn't preach for the sound of guns — And 1-1-1...

And I can't stop shaking ------

Chris White

Butcher's Tale
(Chris White)

"In 1968 I was a 20-year-old university student in Philadelphia. Once a week, I'd head into downtown Philly to shop for records. On a meager student's allowance, I shopped for bargains. My favorite section: 10 singles for a dollar, usually unwanted 'promo' copies of failed attempts at Top 40 hits. On one such shopping trip, I came across 'Butcher's Tale.' I had lost track of The Zombies. It had been three years or so since their US heyday. Here was a single on the Date label, a CBS subsidiary known only for artists like Peaches & Herb and The Arbors. No successful albums ever came out on Date.

My first thought: Were these the same Zombies? The 'C. White' writing credit answered that. Could this be a proper release, maybe to fulfill a contractual obligation? Of course, for 10 cents, I brought it back to my apartment, and listened to the most affecting, saddest anti-war song ever. Every syllable in every verse is just right – the sound of the words, turns of phrase, the meter. My blood boiled at the cozy complicity between the church and the state. I saw the battlefield horror through the narrator's eyes. I experienced his revulsion and knew he'd never be able to get these horrors out of his head, a graphic description of PTSD years before it entered into popular parlance. The spare, ghoulish organ accompaniment ties the battlefield abroad to the church at home. It's so vivid, so real, and you get the whole story in 2:45, not a second wasted."
- Cliff Burnstein, artist manager and co-founder of Q Prime

Chris: My uncle was killed at the Battle of the Somme in 1916 when he was just 16 years old. I had been reading about the battle, and, while driving to a Zombies rehearsal one day, I was suddenly overcome by the thought of 60,000 casualties before breakfast on the first day of the battle. I was so overwhelmed by the waste of human life that I had to pull the car over. I wrote this song on an old upright American pedal organ that I had in our flat. I was a bass player and that's the worst instrument in the world to write a song with. I knew I needed to write songs, but when the mood struck I'd noodle around on the piano or the guitar or whatever I could use.

The track was originally called "Butcher's Tale (Western Front 1916)," but someone at the record company thought he knew better and changed the date to 1914 on the album cover without telling me. I think someone thought the date was wrong since the War started in 1914. But the battle was in 1916. We were still young and we didn't know about the title change until the record came out. I kept having to explain to people, "No we got it right, but somebody else changed the title." We tend to not put the 1914 on there now.

Hugh: It was such a different song and is a unique stand-out track on the album. When we recorded it, it seemed like it should just be Chris singing it and Rod playing the harmonium.

Chris: I wrote it for Colin to sing, but he said, "Your weak little voice suits it very much." I have a quavery voice, basically. I was totally unsure about it. When you have a voice like Colin Blunstone that you're writing for, you don't really want to try to compete with that!

Colin: At the time I just couldn't imagine this song fitting in on the same album with jaunty songs such as "Friends of Mine." I said I didn't want to sing it, so Chris did. Now I kind of regret not at least having a go at it but, in the end, Chris did a great job. It was probably all for the best!

Rod: "Butcher's Tale" gave me chills. In some ways, this is still my favorite track on the album. When Chris first sang it to us I said, "That's brilliant! Chris, you've got to sing it." Colin remembers that he felt uneasy about singing it and preferred Chris to sing it. I think it was Chris' idea to use the harmonium because he had a late 19th century harmonium in his room of the flat we shared together. We actually took it into the studio and used it for the recording. I always regretted that the record company, in their wisdom, saddled us with the wrong date in the title.

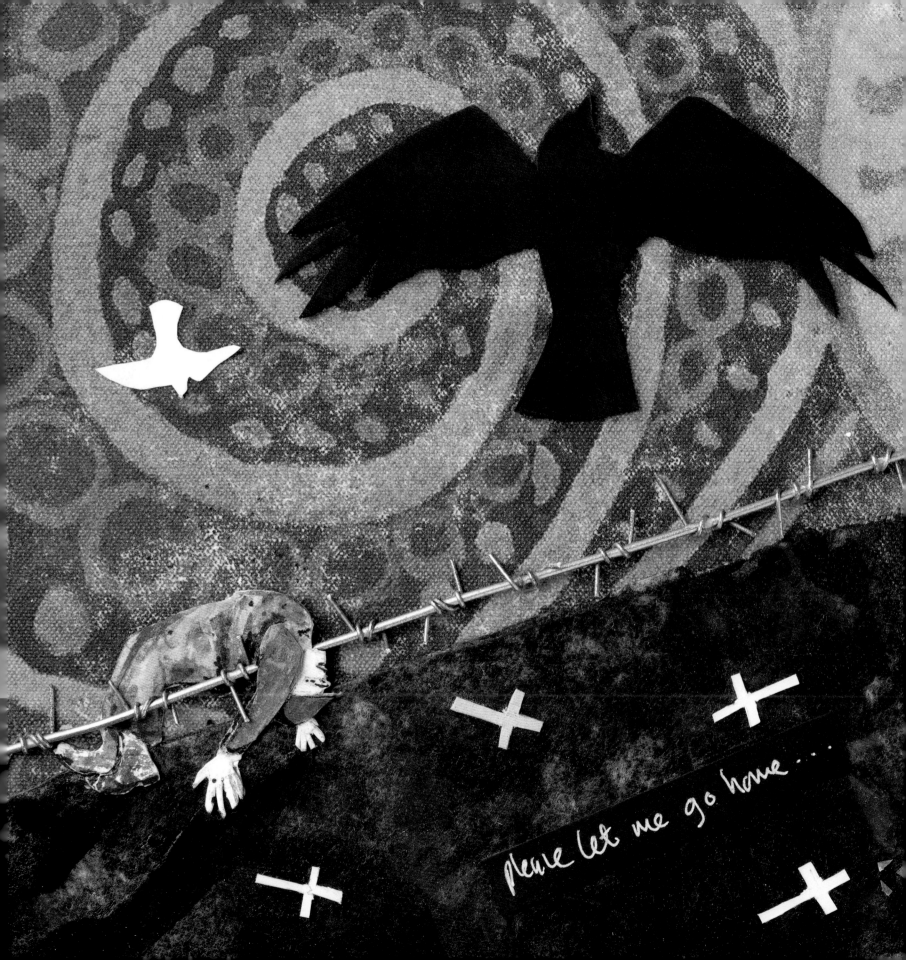

please let me go home

Friends of Mine
(Chris White)

"One of the most captivating aspects of The Zombies' best work are the things that are unsaid – those mysteries that are only hinted at obliquely. Even from the beginning. What exactly did she lie about? To what extent is she not there existentially as opposed to geographically? That thread of things being better left unsaid lyrically permeates nearly all of the band's work from start to finish, and very few artists have ever done it better.

Odessey and Oracle might be the classic study, starting off with a song casually noting that, after a period of adjustment, perhaps the song's subject might reveal to her patient lover what exactly happened during her "prison stay." Say what? And it ends with a song asking a potential partner's name, what her daddy does, and whether he was, indeed, as rich as the singer. This is a pick-up line?

But it is the song 'Friends of Mine' on that album that continues to resonate for me even now. It sits on an album otherwise devoted to consistently gloomy and disheartening topics: a prisoner's return; a woman who will 'grow old and die' without receiving a single rose; a spurned lover, alone and waiting for his rival to depart; a man sipping his drink in the corner, 'far too numb to think' (actually in two separate songs!); an odd dream that soothes the wanderings of a 'troubled brain'; and, most memorably, the man who has seen his friend hang on the wire 'like some rag toy,' who now can't stop shaking. Yikes.

And it is exactly because of those recurring dark tinges that the upbeat 'Friends of Mine' serves as an emotional relief in the programming. It is a song praising the strength and power of love, despite overwhelming darkness. 'It feels so good to know two people / So in love.' Who would think to say such a thing? Maybe someone with his or her own dark history. 'And when I feel bad / When people disappoint me / That's when I need you two / To help me believe.' The song then counts off seven separate couples by name – apparently a lot of people believe in this love stuff, no? And it not only makes the world go round, it not only soothes the troubled soul, it gives this song its singular final spoken lyric of 'Ahhhhh.' And it provides a welcome respite from the gloom 'n' doom that otherwise gloriously pervades *Odessey and Oracle* so unforgettably." *- Dave DiMartino, music journalist*

Friends of Mine

When we're all in a crowd
And you catch her eye
And then you both smile
I feel so good inside
And when I'm with her
She talks about you
The things that you say
The things that you do

Chorus: It feels so good to know two people
So in love, so in love

They are friends of mine, they are friends of mine
 Joyce and Terry —— Paul and Molly
And they've got something it's so hard to find
 Liz and Brian —— Jay and David
They are friends of mine, they are friends of mine
 Kim and Maggie —— June and Duffy
And they've got something you don't often find
 Jean and Jim - and Jim and Christine

When she takes your hand
When the world stays outside
That's something to see
That's nothing to hide
And when I feel bad
When people disappoint me
That's when I need you two
To help me believe
 Chorus

Chris White

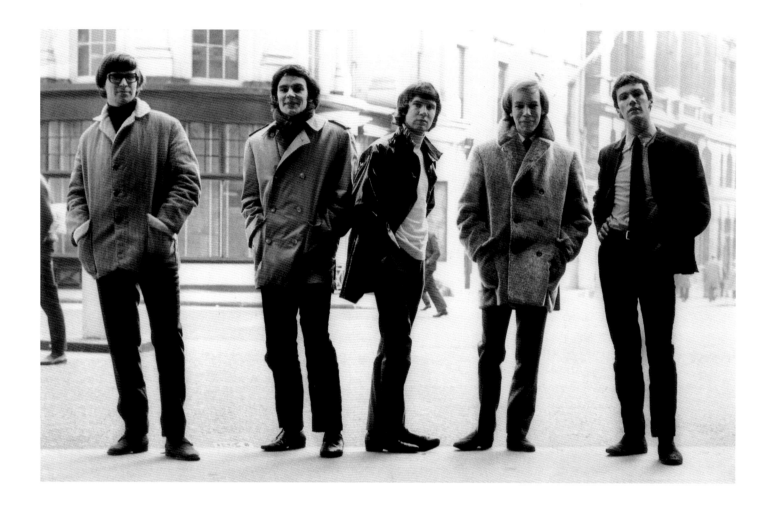

Chris: In my flat one day, I started writing about several friends who were in the "first flush of love." Originally it was a slow song, but in rehearsal with the band Rod suggested it should be more up-tempo. We tried it that way and it worked much better. We knew it needed a chorus backing and we thought we should add the names of couples we knew. Unfortunately, there are only two couples still together! C'est la vie.

Colin: All the names chanted over the chorus were actual friends we had. Hearing this song immediately takes me back to fond memories of a long time ago.

Rod: Sadly, most of the couples mentioned have either split up or died now!

Time of the Season
(Rod Argent)

"There was a buzz about The Zombies that was unlike any other band out at the time. They were a breath of fresh air, interested in incorporating new sounds in their recordings, as well as writing cleverly crafted songs with really superb arrangements. I recall them being quite confident and well-rehearsed, and I enjoyed working with them. I feel proud to have been the recording engineer for 'Time of the Season,' which has become a classic track from the *Odessey and Oracle* album. I will always remember the recording session in #3 Studio at Abbey Road."
- Geoff Emerick

"I was aware of The Zombies when they first arrived as part of the British Invasion, but they had frankly slipped off my radar until Al Kooper told me they'd made a wonderful new album filled with great songs that deserved a wide audience. As luck had it, CBS already had the rights to release *Odessey and Oracle* in America, and, after listening to the album, I agreed with Al. Although it wasn't the first single, 'Time of the Season' went on to be a tremendous, era-defining hit that still sounds fresh and hopeful. It always brings a smile every time I hear it. And *Odessey and Oracle*, over the years, has gotten all the accolades it's always deserved." **- Clive Davis**

Time Of The Season

It's the time of the season
When love runs high
In this time, give it to me easy
And let me try with pleasured hands

To take you in the sun to promised lands
To show you everyone
It's the time of the season for loving

What's your name?
Who's your daddy?
Is he rich like me?
Has he taken any time
To show you what you need to live?

Tell it to me slowly
Tell you why
I really want to know
It's the time of the season for loving

What's your name?
Who's your daddy?
Is he rich like me?
Has he taken any time
To show you what you need to live?

Tell it to me slowly
Tell you why
I really want to know
It's the time of the season for loving

Rod Argent

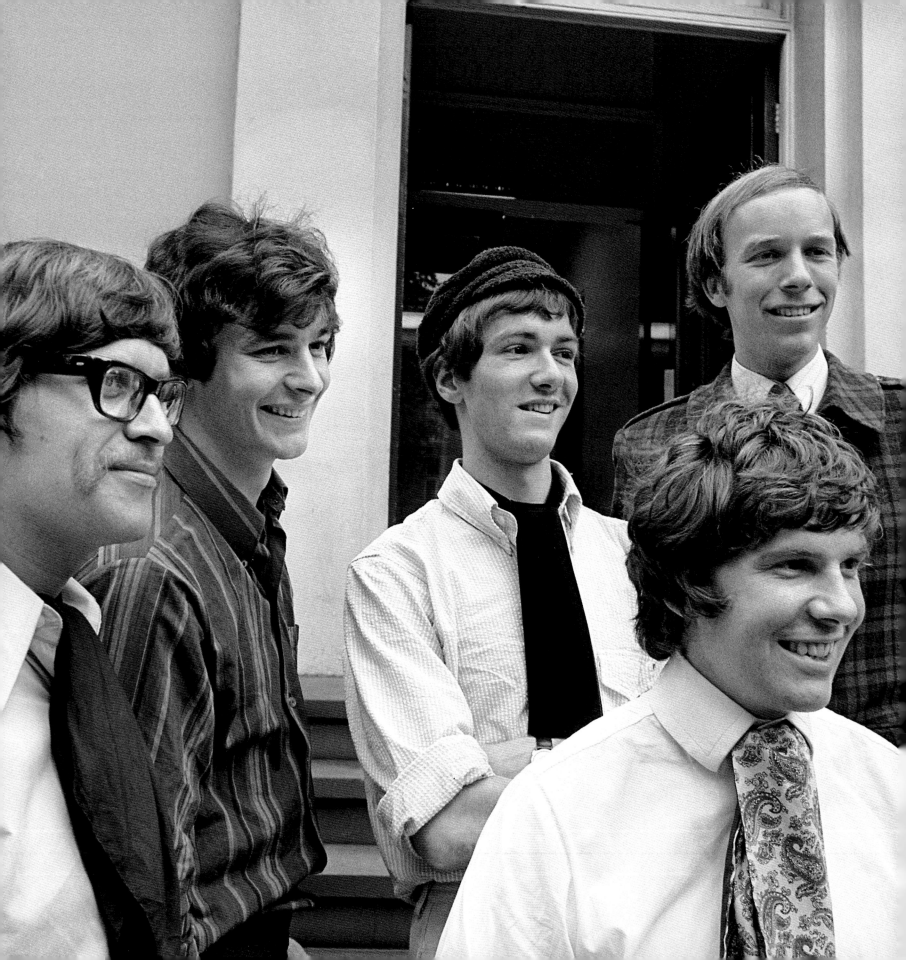

Rod: We needed one song to finish the album, so I went away and wrote it in the flat I shared with Chris. I remember playing the idea through to Chris and telling him I thought it could be a hit. It felt simple and soulful. On our very first session as a band we had recorded George Gershwin's "Summertime." That song has the line about the rich daddy, so I include a slight affectionate nod to that with my own line, "What's your name? Who's your daddy / Is he rich like me?"

Colin: "Time of the Season" was the last song we recorded for the album. It had just been freshly written and I wasn't particularly confident of the phrasing – or even the melody! Time and money were running out, so I struggled to complete the lead vocal with the clock ticking ever louder in my mind.

Rod: I remember this song as being written almost immediately before we recorded it. I've always been great friends with Colin throughout our whole lives, but that doesn't mean we didn't have some blazing arguments sometimes. Colin was singing and, since he didn't know it thoroughly, I was in the control room coaching him. He got really exasperated with me at one point and said, "If you know so much, why don't you get in here and fucking sing it?" We were going back and forth, and it was getting very heated.

Colin: As our fans well know, Rod and I had a few fiery moments. It's kind of funny, all these years later, to think back and remember that, while singing, "It's the time of the season for loving," Rod and I were exchanging extremely terse comments and making veiled threats of physical violence!

Rod: These things happen, and it's soon forgotten.

Chris: Rod, initially, had to "strongly convince" Colin about some melodic phrasing that he wanted. In the end Colin sang it perfectly and the LP was complete. The whole album was then mixed in mono and the £1,000 budget that CBS had advanced us was spent. Then the record company said that we had to mix it again in stereo because that was becoming popular. With the budget spent, Rod and I had to pay another £1,000, out of our own pockets, to mix the album again in stereo.

Rod: Chris White and I shared a flat with Terry Quirk, who worked as a teacher at an art school. We loved his style, so when the album was finished we asked him to come up with an idea for the cover. He came up with his first drawings and we loved it. We said, "Look, we're off on tour, but we love what you're doing, so just finish it up." When he did he took it to CBS. When we came back from the tour we went to the label and saw the final cover. We looked at it and said, "It's great, but Terry spelled Odyssey wrong." CBS said, "Sorry, but we're too far along in the schedule. We can't change it." I said, "Well, I'll tell you what. We'll say it's a play on the word 'ode' in combination with the word odyssey, which is a journey or adventure. We'll say it's a journey of words and songs." We told the other guys that, too. I was telling this story in an interview after Colin and I got back together for the current incarnation of the band. He looked at me with his mouth wide open and said, "What? How come you've never told me that after all these years?" It was a closely guarded secret for a long time!

Terry Quirk: For a long time they kept it going that it was deliberate. It's an odessey – a journey in verse." But later, it was credited as being a mistake. A friend of ours challenged Rod and said, "You know, you never paid Terry for the album, did you?" And he said, "No. I'll pay him when he gets the spelling right."

Rod: *Odessey and Oracle* came out in the UK and got great reviews, but it didn't sell. We released the first single, which I think was "Care of Cell 44," but it hardly got any airplay. We decided to break up. The reason we broke up was purely commercial. Any royalties we were due on those early records came through to us as artists, but by 1967 those monies had dried up a bit. From a songwriting point of view, our records were played all over the world. Because we had honest publishers, Chris and I always had a good income. The rest of the guys, though, a large amount of their income came from UK gigs. There was quite a lot of ripping off that went on and we never made the money we should have from public performances. The non-writers, Colin, Paul, and Hugh, were short of money. Paul finally said, "Look guys, I'm getting married. I've got to change my path because I haven't got enough money to sustain a marriage." My memory is that Colin said, "Yeah, it's the same for me, really. This is going nowhere." We were all friends, but that was just the reality.

Unbeknownst to us, Al Kooper had been hired by Clive Davis as the hot new A&R guy at CBS Records in the US. He was sent to England to check out what was going on and came back with 200 albums. He went up to Clive and told him that *Odessey and Oracle* stood out "like a rose among thorns." Clive said, "We have that album and we passed on it!" Al told him, "We need to release it." Clive agreed. The first single they released was "Butcher's Tale," which was crazy. It's still one of my favorite tracks on the album, but it's not a single. Next, they released "Care of Cell 44," then "Friends of Mine." Nothing happened, so, as a last resort, Al wanted them to release one more single.

Hugh: Al suggested putting out "Time of the Season." They did and nobody played it. After a while, though, it started hitting on one radio station in Boise, Idaho. Then it spread to neighboring stations, then more stations, and more stations.

Rod: In those days, songs could gradually catch the public's attention in one region and spread out with a ripple effect. We didn't even know it was gaining momentum for six months until it was already shooting up the charts. We couldn't believe it! We had a huge hit, but had already broken up.

Colin: Unlike "Care of Cell 44" I never thought "Time of the Season" was a hit single. Then it sold about two million copies! Over the years that has made me more than a little reluctant to choose singles from albums.

Chris: If a song is successful in itself that's reward enough. If it's commercially successful, that's doubly rewarding. Recognition has been very rewarding. To be recognized for something we loved doing as being part of musical history is rewarding and very nice to hear. But if a song works for you, it's successful. If it's commercially successful, that's wonderful. And you can buy lunch!

Rod: We were offered a lot of money to re-form, but it didn't feel like the right thing to do. I had already started my band, Argent, and we were working on Colin's first solo album, so we decided not to do it. If it hadn't been for Al Kooper, though, our whole career path in life could have been very different. The whole thing came together quite magically, and I'm so grateful that Al kept it from falling into obscurity.

Hugh: I'm absolutely thrilled and honored to be on the album and to have been a part of it. I think I can safely say it's gone into the history of pop music as the biggest sleeper album ever!

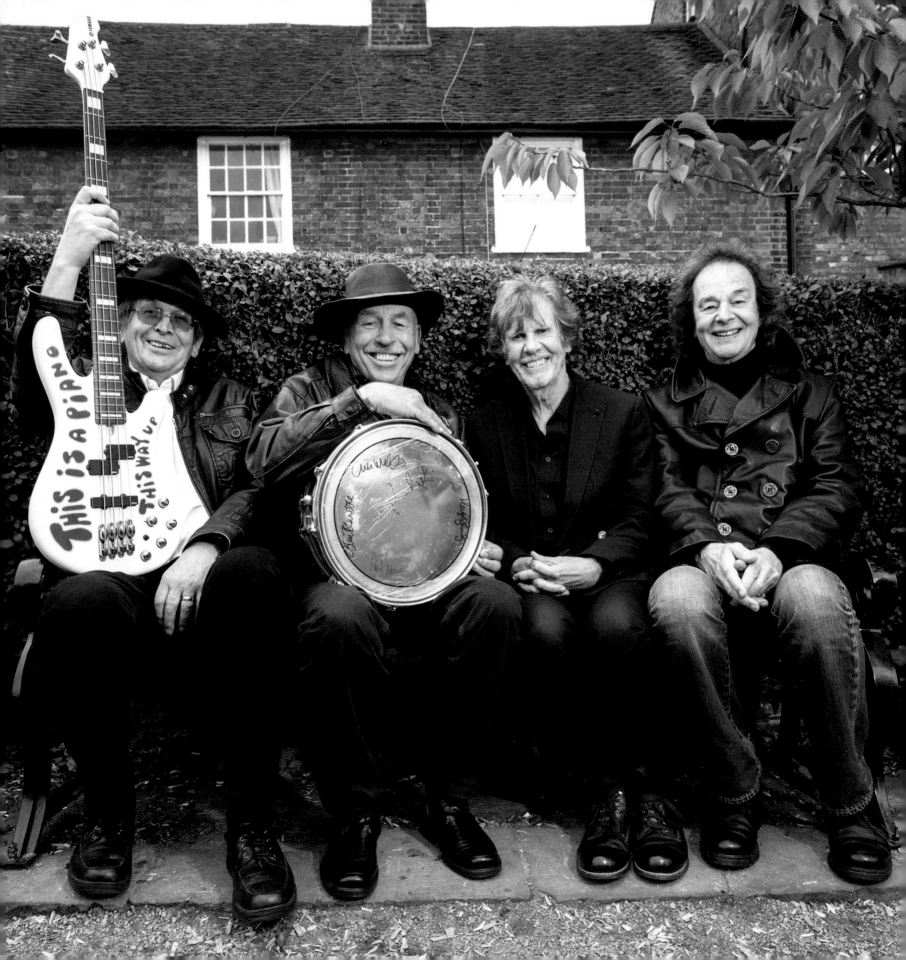

STILL GOT THAT HUNGER: THE STORY CONTINUES...

"I've always loved The Zombies and the song, 'She's Not There.' It's a great song, and it really captures the mood of that era, but it's also timeless! Their sound is dynamic and has a real mysterious feel to it. A lot of their songs remind me of all the great experiences that Labelle had while we were living in London. I'm happy that they're still doing their thing!" - *Patti LaBelle*

When The Zombies opted not to re-form in the wake of the success of "Time of the Season" in 1969, unscrupulous booking agents put together fake versions of the band and sent them on the road across the US. Coincidentally, one of these groups included Frank Beard and Dusty Hill, who would go on to form ZZ Top.

Meanwhile, Rod Argent formed the band Argent in 1969, which included production and songwriting contributions from Chris White. They released several successful singles, including the Top 5 hit "Hold Your Head Up" in 1972 and the original version of "God Gave Rock and Roll to You," which hit the Top 20 in the UK the following year. Colin Blunstone embarked on a solo career, while both Paul and Hugh went to work for Columbia Records.

Colin, Hugh, and Chris reconvened The Zombies in 1990 for a one-off album called *New World*, but Rod and Paul only made guest appearances. After three decades, all five original members were together once again at London's Jazz Cafe for the 1997 launch of the *Zombie Heaven* box set. They took the stage and performed two impromptu numbers. In 2000, Rod and Colin joined forces to perform as a duo, releasing an album, *Out of the Shadows*, soon after. They eventually revived The Zombies' name, touring with a group of musicians including Jim Rodford, who was a member of Argent before joining The Kinks in the late 1970s. They released an album of new material in 2004. That same year, the original Zombies reunited for one last performance shortly before Paul Atkinson's death.

In 2008, the four surviving original members came together for the 40th anniversary of the release of *Odessey and Oracle* to perform three shows at the Shepherd's Bush Empire in London. It was the first time they ever played the album, in its entirety, in front of a live audience. A short British tour featuring the original line-up was undertaken the following year.

In 2011, The Zombies released *Breathe Out, Breathe In*, which critics hailed as the band's true return to form. In 2015, they released another album, *Still Got That Hunger*. It was followed by a US tour featuring appearances by Chris and Hugh to play the *Odessey and Oracle* LP for US audiences for the first time. In 2017, the surviving original members have come together once again to commemorate the 50th anniversary of the recording of their landmark album. The current line-up of The Zombies is Rod, Colin, Jim Rodford, Jim's son Steve on drums, and guitarist Tom Toomey.

Breathe Out, Breathe In

The city's sitting pretty
A warm summer wind
Seems to promise something special tonight
There's a look in your eye
And I want to be part of you
Make it all right
Later tonight

We can go to the river
Watch the sun go down
Catch a little music in flight
Let our hearts swell with pride
And the feelings inside of us
Make it all right
Later tonight

Breathe out, breathe in
Tonight we win
Say goodbye to tomorrow
And here let the story begin

Won't you look at the evening
Spread out to the sky
It really is a wonderful sight
As the stars in their millions
Emerge from vermillion
Deepening light
I'll love you tonight
We can roll with the music
Get lost in the sound
Stay until the break of daylight
In this life we are living
We dance to the rhythm
And make it all right
However we might

Breathe out, breathe in
Tonight we win
Catch the stars as they're falling
Treasure the light
Let it shine on our freedom
This wonderful sight
We can live with the rhythm
As long as we learn to
Breathe out, breathe in
Breathe out, breathe in

Rod Argent

Breathe Out, Breathe In

(Rod Argent)

From the *Breathe Out, Breathe In* album
Released May, 2011

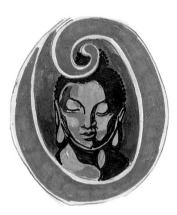

"The Zombies remain fascinating half a century after they began making records for very good reason. Rod Argent started out as one of the finest keyboard players of the period and remains one. The band's classic elements preceded anything like prog; they are present on 'She's Not There' when The Beatles were still rewriting Carl Perkins, and the Rolling Stones carried on monkeying with Motown and the blues. The Zombies were not terribly theatrical – with singers as good as Argent and Colin Blunstone, they didn't need to be – but their music, 'Tell Her No,' and 'Time of the Season' in particular, carried overtones that were ominous, or at least spooky. They were virtuosi who loved rock 'n' roll; serious musicians who wanted to have fun with their listeners, and everybody was invited. All of this is why they have been able to persist while many great bands fell apart.

Their sound isn't any more timeless than the shoreline but, 50 years on, it doesn't seem any less, either. And their recent work continues to creatively balance all these elements and others not described here. They pointed the way to rock as an art without ever betraying the principle of good time music that underlays all the really great stuff. They are as unique as any rock band can be and their staying power is amazing, especially given the high quality of their later work. Here's one of the last stick-to-your-guns originals playing show-and-tell with their history. I don't know if there are secrets here that aspiring contemporary hit makers can use, but it's more than worth the try. In any generation there's only so much room at the top. But The Zombies belong there."

- Dave Marsh, author and music journalist

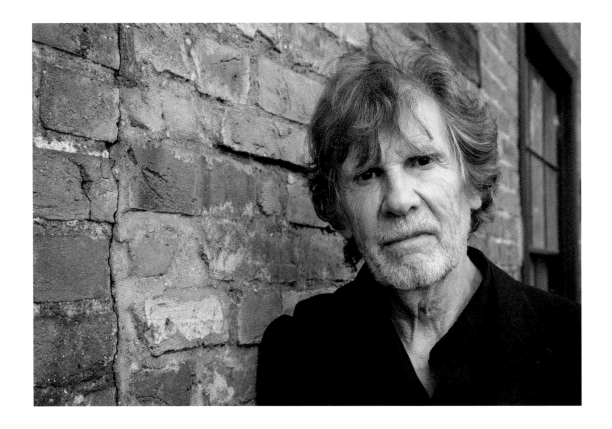

Rod: My cousin Jim Rodford was a founding member of Argent, played with the Kinks, and later joined our current incarnation of The Zombies. His son, Steve, plays drums in the band with us, and Steve has a daughter named Anya, who is a talented actress and singer. One lovely summer evening, just before the recording of the *Breathe Out, Breathe In* album, my wife and I went to hear Anya in a little duo she has with a guy named Gary Sears. They perform the music of Joan Baez and Bob Dylan. We went to the pub, and it was the most beautiful night. It was just a really magical evening, and I was inspired to write this song about the joy of living in the moment and being taken over by hearing wonderful music and enjoying a glorious evening. Hearing Jim's granddaughter sing got me thinking about how fantastic it is to be involved in music.

Colin: This is Rod's song of simmering passion on a summer night in St. Albans, where we all went to school. It's a song that works really well live with the whole band, as well as when Rod and I do acoustic concerts together.

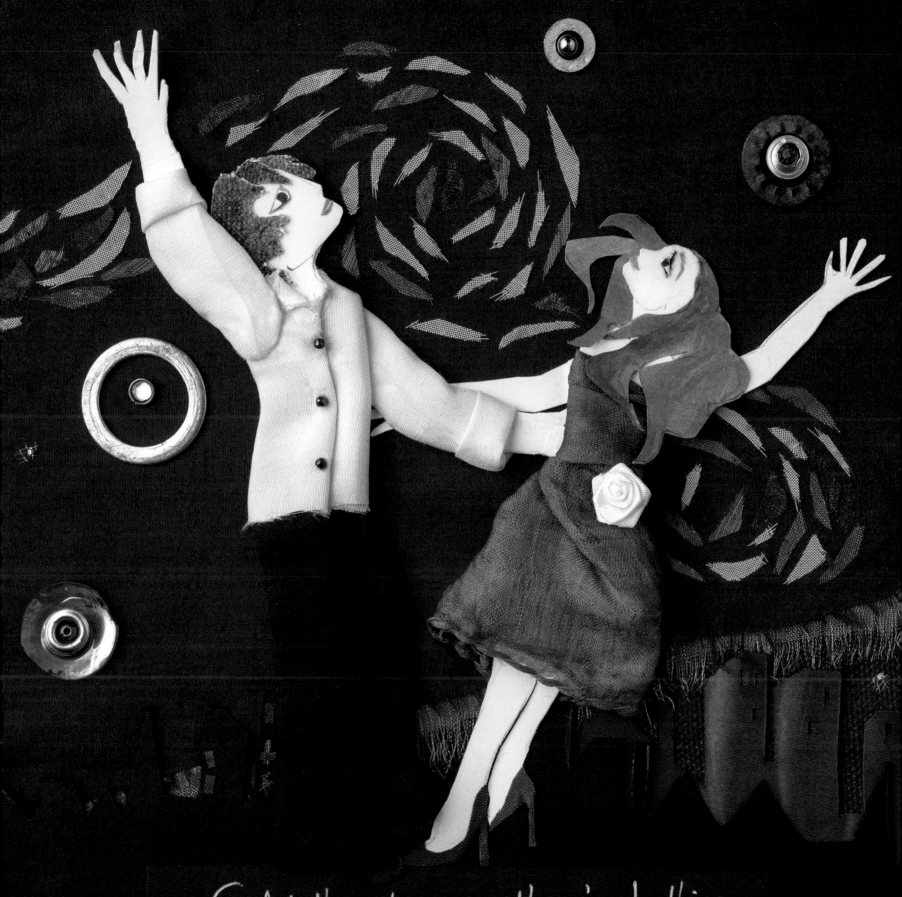

Catch the stars as they're falling

Any Other Way

(Colin Blunstone)

From the *Breathe Out, Breathe In* album
Released May, 2011

"The Zombies got me instantly with 'She's Not There' and 'Tell Her No.' Later, I bought *Odessey and Oracle* while I was in the UK, as it was not released yet in the USA. It totally floored me and, at the risk of my new A&R position at Columbia Records, I bugged Clive Davis daily to put it out. Since then, we have become close friends and I treasure all their music from back then until right this moment. As we are approximately the same age, they constantly embarrass me with their grueling tour schedules; I could *never* survive the itineraries they constantly perform night after night. God bless 'em and their collective talent and endless energy." - *Al Kooper*

Any Other Way.

Still remember seeing you standing there
Alone in a crowded room
Suddenly your presence filled the air
Nothing that I could do
Always knew you were the only one
I never told you so
Thought you'd understand what I had done
When I had to let you go

Thought that we could prove ourselves
Show that we were strong
Should have written everyday
Now I know that I was wrong

If there was any other way
Don't you think I would have found it
by now
Found a way around it somehow
If there was any other way

Left you on a rainy summer's day
I thought you understood
You turned and never looked around again
I knew you never would

We were only children then
Living on borrowed time
Stars were shining in your eyes
Tears were filling up in mine

If there was any other way
Don't you think I would have found it
by now
Found a way around it somehow
If there was any other way
And if the world should end today
I'd take my last breath wispering your name
Wondering if you ever felt the same
If there was any other way.

Colin Blunstone.

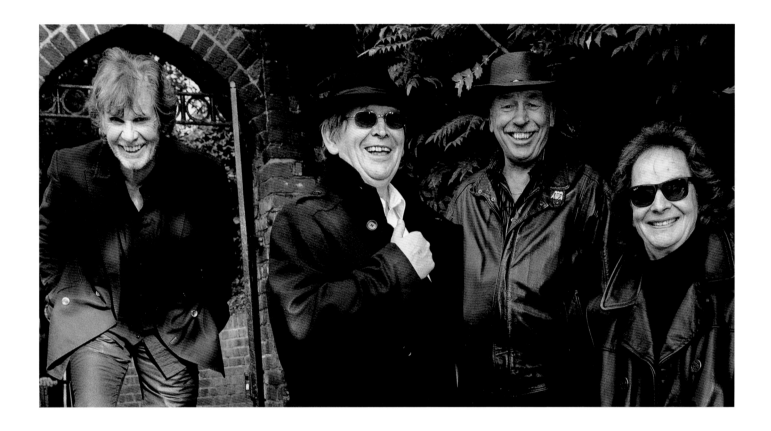

Colin: I usually write lyrics about real people and real situations, and this is no exception. It has quite a sophisticated chord sequence relaying a story of love won and lost many years ago. Amazingly, this song marked the very first time The Zombies made a music video.

Rod: I remember well the recording of "Any Other Way." It was one of Tom Toomey's first sessions after having joined the band, and we'd asked him to work out an acoustic guitar solo for the center section. We were all knocked out with how it was sounding. At that very moment he received a call from his wife, Millie, with the life-changing news of the birth of their first child – an obviously fantastic and important moment! He was so excited, but he couldn't bear to leave for the three hour dash until he'd absolutely completed the solo! As he departed he said, "I'll always remember today!"

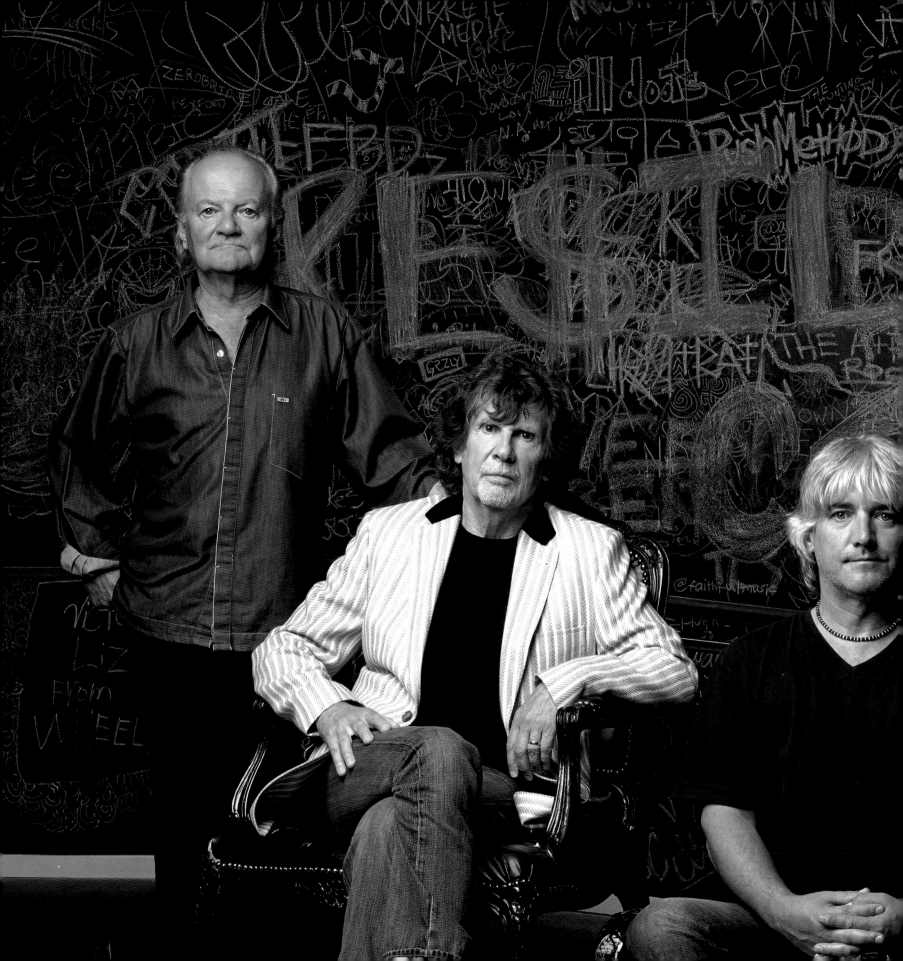

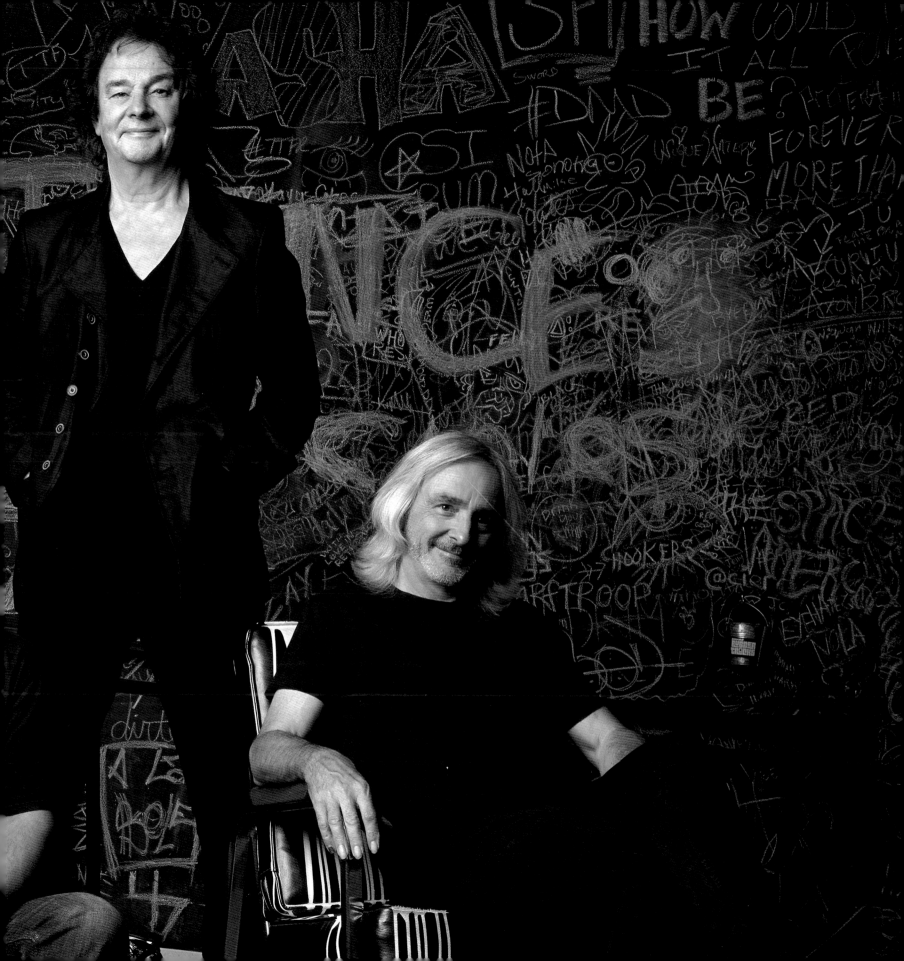

Moving On
(Rod Argent)

From the *Still Got That Hunger* album
Released October, 2015

Rod: Colin and I are energized and motivated the same way we always were when we started out. There's no thrill like writing a song, working out the arrangement, getting together with the band to hear it come together, and then, if you're lucky, hearing it played on the radio. It's the most magical journey and the most energizing thing you could possibly imagine. We love playing all the old music, but always within the context of a creative path forward. It's all about looking ahead.

This song was started in 1977 when Elvis died. He was my first rock and roll mentor, and I just couldn't believe he was gone. I felt lost. I wrote this one couplet, "I'm moving on like a ship sailing windblown / August moon can you tell me where I'm bound." I forgot about the song completely, but then, years later, I completed it just before we finished the *Still Got That Hunger* album. It wasn't about Elvis anymore, but that original idea was the start of the lyric. I was inspired to finish it when I read a story about a young woman whose life had been tragically altered. She said the phrase you often hear, "What doesn't kill me makes me stronger." I incorporated her story and a few things of my own into the song, but I changed it to, "What doesn't kill me will fill me with life."

Moving On

I'm moving on
Like a ship sailing wind-blown
Who can say where the rainbow may be found?
 Take my chance
 And I'll sail to tomorrow
April moon - can you tell me where I'm bound?

I'm moving on
From this place of confusion
It's goodbye to trouble I'm leaving behind
 In my life
 No more grieving or sorrow
Won't allow the darkness my soul to define

 I won't cry for the past
 For I've refound my freedom at last
 I won't shy from the strife
 What doesn't kill me will fill me with life

And I'm moving on
To my dreams of tomorrow
Thrilled to be wherever my soul may be bound
 Who can tell
 Where the journey may lead me
Who can say where the rainbow may be found?

Rod Argent

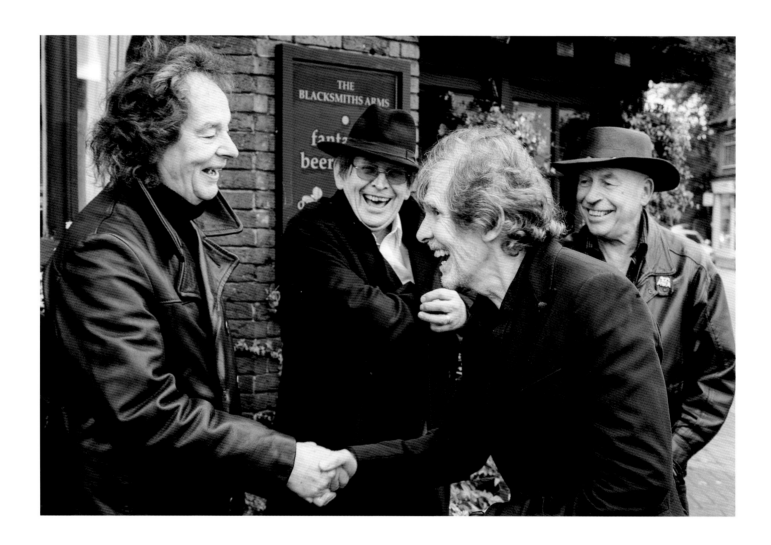

I won't cry for the past

Chasing The Past
(Rod Argent)

From the *Still Got That Hunger* album
Released October, 2015

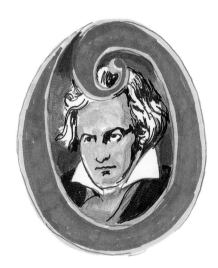

Rod: This is probably my favorite song on the *Still Got That Hunger* album. It came together in the way some of the early songs used to in that I realized there were all sorts of influences that weren't conscious. It starts off almost like a Bach solo piano thing. The sentiments of the song are very much what I believe, which is that it's important to look forward and get excited about the future. There's no point in chasing the past. It goes from that into some wild Jimmy Smith-influenced organ. Then you get the really interesting harmony voicings in the chorus. After that comes a nice rock guitar solo before finishing almost acapella. It's got some really interesting components in it.

Colin: This is one of my favorite songs from our latest album. Those fabulous organ and guitar solos and the trademark Zombies harmonies remind me why I love my job!

Chasing The Past

You were the one
Who told me
"Don't look back"
When I was younger

You made the sun shine through
And changed my world from black
- Gave me that hunger

And there is not another place
That I would rather be than here
No case for chasing the past
 Yesterday; it's gone
 It's just as well
Now we'll take tomorrow, and make it tell

You were the one
Who made my life complete
When I was younger

You let the sun shine through
And made it all so sweet
Still got that hunger

And there is not another place
That I would rather be than here
No case for chasing the past
 Yesterday; it's gone
 It's just as well
Now we'll take tomorrow, and give it hell!

Rod Argent

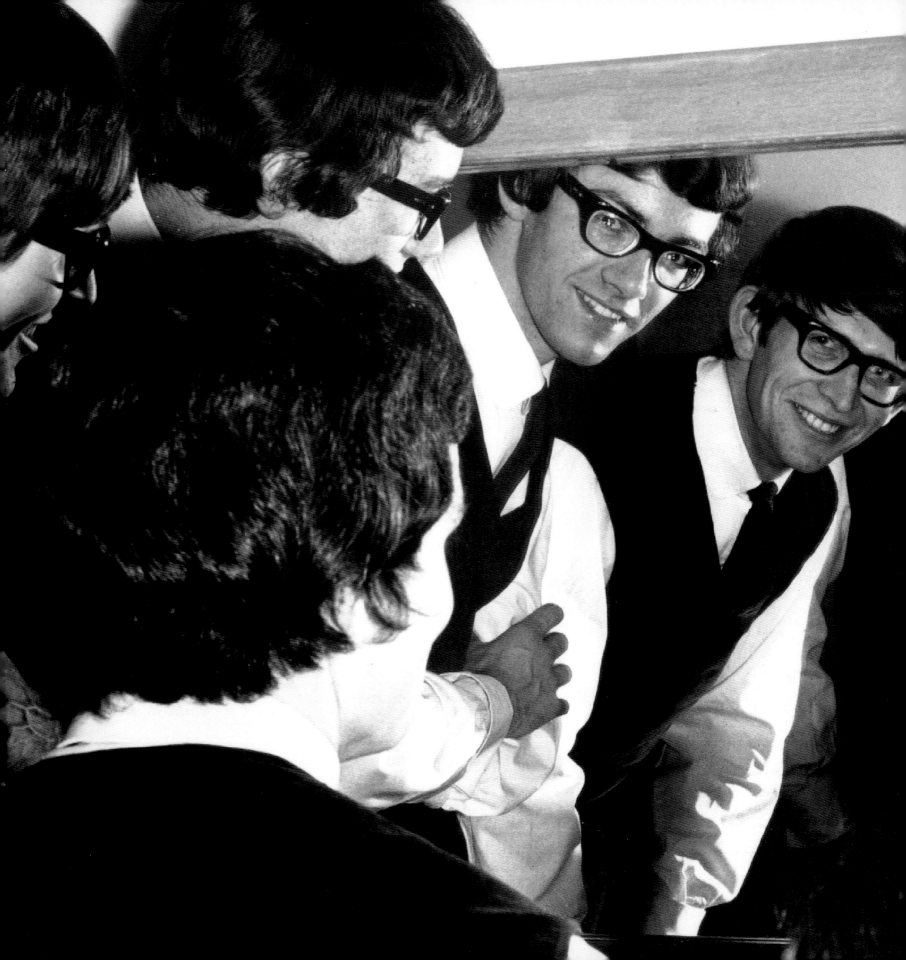

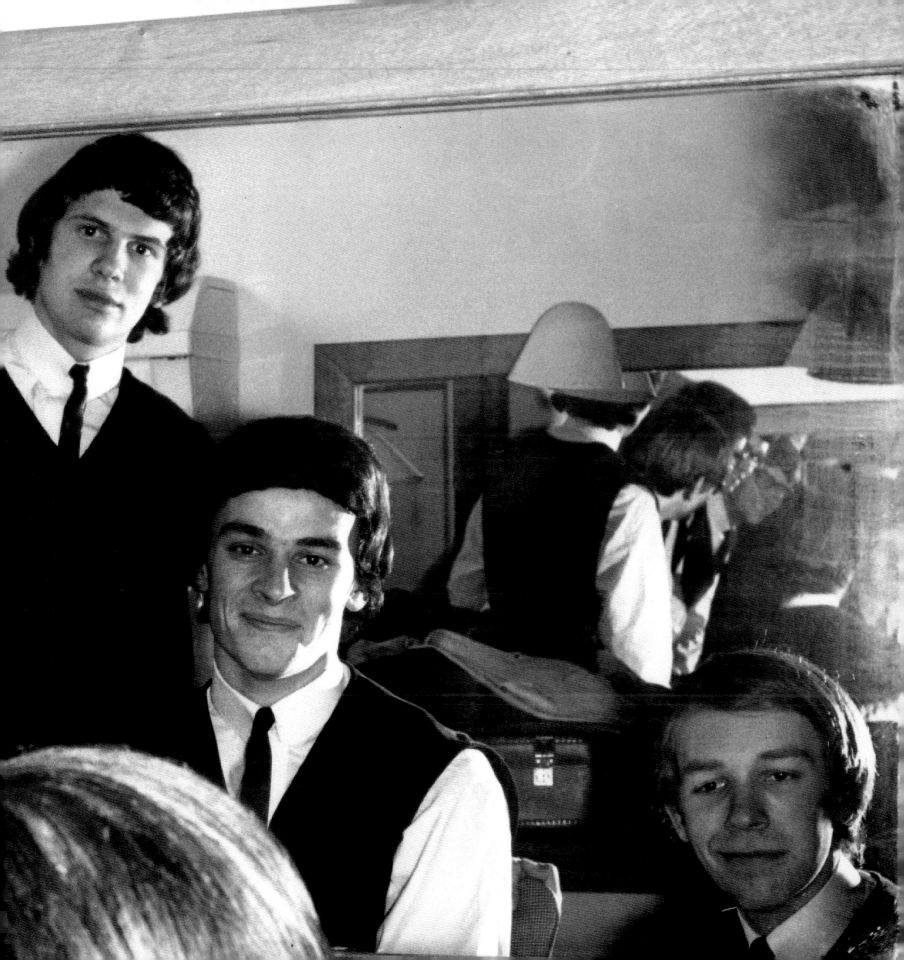

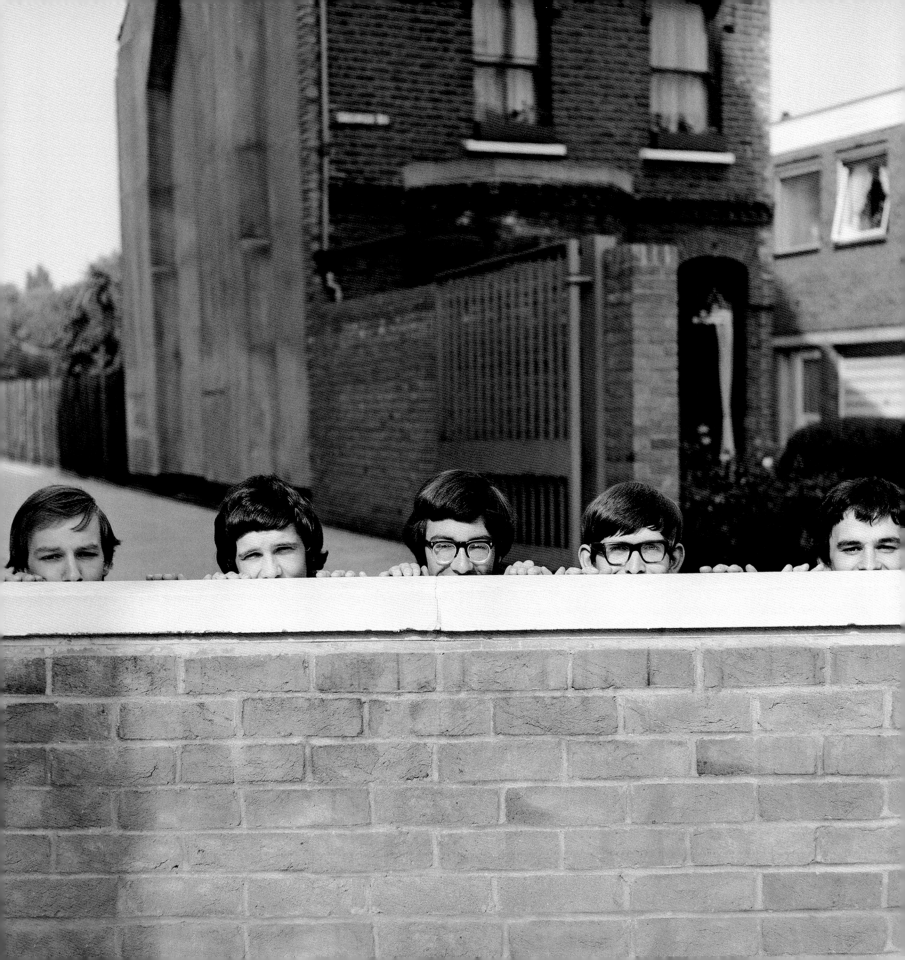

Acknowledgments

We want to thank our loving families: The Argents – Cathy, Elesa, Mark, Phyllis, and Roselyn; The Atkinsons – Helen, James, Lucy and Matt; The Blunstones – Susi and Rosy; The Grundys – Caroline, Edward, Hayley, Helen, Louise, Margaret, Susan, Tracy; The Whites – Clare, Jamie, Jackson, Kat, Orton, Sacha, Matthew and Amor Aguado.

Many thanks to Al Kooper; without his enthusiasm and persistence, *Odessey and Oracle* may have never been released in America.

Also to Chris Tuthill, Melani Rogers and Fiona Bloom for their relentless championing of this band.

We appreciate everyone who contributed to this book, including Nick Bockrath, Bob Boilen, BØRNS, Cliff Burnstein, Kevin Cronin, Christopher Cross, Clive Davis, Dave DiMartino, Geoff Emerick, Susanna Hoffs, Patti LaBelle, Victoria Legrand and Alex Scally of Beach House, Dave Marsh, Matthan Minster, Graham Nash, Alec Palao, Tom Petty, Nate Ruess, Carlos Santana, Ken Sharp, Matt Shultz, Matthew Sweet, Paul Weller, Brian Wilson, and Lee Zimmerman.

Thanks, also, to Vivienne Boucherat and Terry Quirk for their vision.

And everyone who helped make this project possible, including Lexi Ben-Meir, Carole Broughton, Dave Brolan, Rory Bruton, Giulia Calani, Russell Carter, Carol Cherman, Tom Consolo, Alison Elangasinghe, Adam Fells, Jason Foster, Marya Glur, David Hirshland, Carol Kaye, Natalie Kelapire, Mary Klauser, Margo Lewis, Claire Moon, Cree Miller, Tony Nourmand, Pam Ricklin, Steve Rose, Phil Sandhaus, Dalton Sim, Monika Tashman, Christine Zebrowski, and the wonderful teams at BMG and Reel Art Press.

Photo Credits

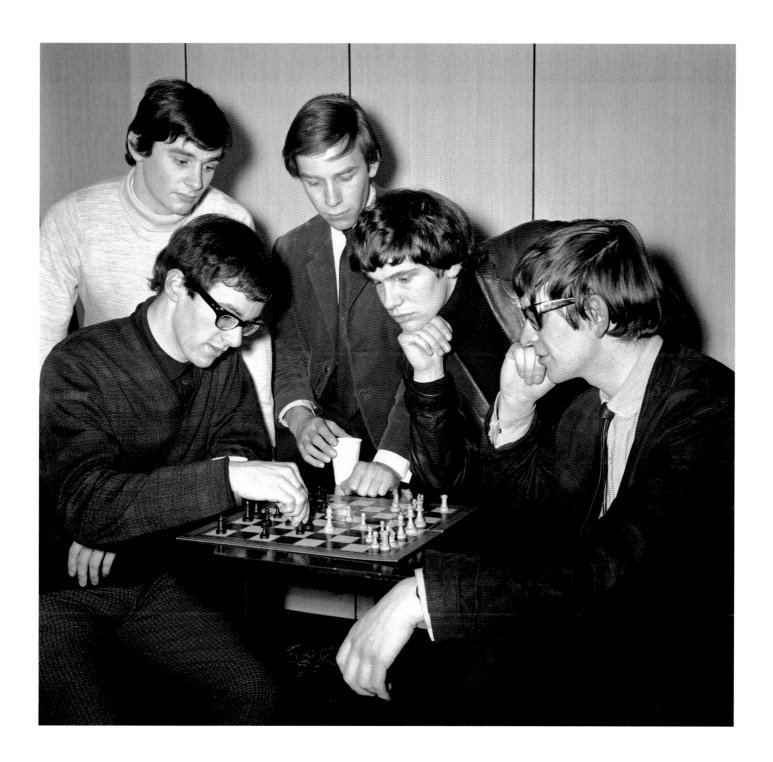

Art Direction and Design by Joakim Olsson

First published 2017 by Reel Art Press/BMG Books

Reel Art Press is an imprint of Rare Art Press Ltd., London, UK

www.reelartpress.com
www.bmg.com

First Edition
10 9 8 7 6 5 4 3 2 1

ISBN: 978·1·909526·44·0

Printed by Graphius, Gent.